Outer & Inner Space

Outer & Inner Space

Pipilotti Rist, Shirin Neshat, Jane & Louise Wilson, and the History of Video Art

John B. Ravenal

With essays by

Laura Cottingham

Eleanor Heartney

Jonathan Knight Crary

Virginia Museum of Fine Arts

Outer & Inner Space: Pipilotti Rist, Shirin Neshat, Jane & Louise Wilson and the History of Video Art

This book was published to coincide with *Outer & Inner Space: A Video Exhibition in Three Parts,* organized by the Virginia Museum of Fine Arts, Richmond, Virginia, USA.

Part One

January 19–March 17, 2002

Video Installation by Pipilotti Rist, *Sip My Ocean*

Single-Channel Videos by Vito Acconci, Eleanor Antin, Lynda Benglis, Dara Birnbaum, Cecelia Condit, Joan Jonas, Paul McCarthy , Nam June Paik, Martha Rosler, William Wegman, Hannah Wilke

Part Two

April 6–June 2, 2002

Video Installation by Shirin Neshat, *Rapture*

Single-Channel Videos by Marina Abramović & Ulay, Vito Acconci, Klaus vom Bruch, Shirley Clarke, Juan Downey, Mona Hatoum, Gary Hill, Joan Jonas, Charlemagne Palestine, Howardena Pindell, Daniel Reeves, Edin Vélez, Bill Viola

Part Three

June 22–August 18, 2002

Video Installation by Jane & Louise Wilson, *Stasi City*

Single-Channel Videos by Ant Farm & T. R. Uthco, James Byrne, Peter Campus, Dan Graham, Mary Lucier, Branda Miller, Bruce Nauman, Marcel Odenbach, Nam June Paik & Jud Yalkut, Charlemagne Palestine, Richard Serra, Steina, Bill Viola

ISBN 0-917046-61-7
Printed in the United States of America

Produced by the Office of Publications
Virginia Museum of Fine Arts
2800 Grove Avenue
Richmond, VA 23221-2466 USA

Distributed by the University of Washington Press

Senior Editor: Rosalie West
Project Editor: Monica S. Rumsey
Editorial Assistance and Indexer: Anne Adkins
Graphic Designer: Jean Kane
Composed by the designer in QuarkXPress
Typeset in Officina Sans with Helvetica Narrow
Printed on acid-free 100 lb Strobe Dull by B&B Printing, Richmond

Front cover: Pipilotti Rist, detail, *Sip My Ocean,* 1996. See pages 32–33.

Back cover, top: Shirin Neshat, detail, *Rapture,* 1999. See page 54.

Back cover, bottom: Jane & Louise Wilson, detail, *Interview Room, Hohenschönhausen Prison,* from *Stasi City,* 1997. See page 77.

Table of Contents

Sponsors

This exhibition and book are made possible by an Emily Hall Tremaine Exhibition Award. The Exhibition Award program was founded in 1998 to honor Emily Hall Tremaine. It rewards innovation and experimentation among curators by supporting thematic exhibitions that challenge audiences and expand the boundaries of contemporary art.

Additional funding was received from The Council of the Virginia Museum of Fine Arts and the Fabergé Ball Endowment. Other contributors include Marion Boulton Stroud, the Friends of Art of the Virginia Museum of Fine Arts, The Horace W. Goldsmith Foundation, Mr. and Mrs. T. Fleetwood Garner through The Community Foundation, Bill and Sara Borowy, and LaDifférence. State-of-the-art digital video equipment by Zenith Electronics Corporation.

Foreword

The Virginia Museum of Fine Arts entered the new century with plans for a major physical expansion that will, among other benefits, greatly improve our ability to display and interpret contemporary art. For this reason, we feel it is especially timely to introduce our audiences in greater depth to the field of video art—the most significant medium of artistic expression to emerge over the last half of the previous century.

With diverse cultural backgrounds ranging from the United States to England, Switzerland, Germany, Iran, and Korea, the nearly forty artists represented in *Outer and Inner Space* highlight the universal power of this electronic medium. In addition, with three multi-projector installations representing some of the most important trends in recent video art, and a host of single-channel works from the late 1960s to mid-1980s, visitors to the exhibition and readers of this book have an unusual opportunity to experience the past moving into the present.

As John Ravenal notes in his introduction, viewers will react differently to these works depending on their age and experiences during the often tumultuous last three decades of the twentieth century. For all of us, however, *Outer and Inner Space* offers a chance to reflect on the tremendous artistic, cultural, and technological changes that have brought us to where we are today.

The Museum is grateful to John Ravenal for organizing the complex but highly engaging exhibition for which this book serves as a catalogue. We are also very grateful to the three noted experts in the field of video art—Laura Cottingham, Eleanor Heartney, and Jonathan Knight Crary—whose essays build upon John's incisive introduction and provide a stimulating counterpoint to his thoughtful discussion of the individual artists and their work.

We would also like to recognize the lenders to this exhibition and the many staff who contributed their expertise to this project. Special thanks are also due to the Emily Hall Tremaine Foundation and other generous donors who have enabled the Museum to continue our commitment to contemporary art in general and to bring a vitally important recent art form to new audiences.

Michael Brand
Director
Virginia Museum of Fine Arts

Preface & Acknowledgements

This exhibition came about in response to several needs and interests. First, I wanted to bring examples of some of the best recent international video installations to Virginia and the region. In so doing, I drew upon my prior experience at the Philadelphia Museum of Art, which included organizing a series of solo and group exhibitions for the museum's Video Gallery. I also wanted to build upon a relevant but somewhat limited history of video exhibitions at the Virginia Museum of Fine Arts that includes, among several others, *Video Works 1: William Wegman* in 1982, *Video Installations: Doug Hall and Mary Lucier* in 1986, and *Bill Viola: Slowly Turning Narrative and Other Works* in 1992.

While bringing the Museum's video exhibition program up to the present by showing works by a younger generation of video artists, I also wanted to expose viewers to a broad selection of seminal works by the pioneering generations that preceded them. Further, by placing recent works in the context of early examples, I hoped to educate visitors to an encyclopedic fine arts museum about the overall development of a defining contemporary medium. Juxtaposing videotapes from the 1960s, 1970s, and early 1980s with video installations from the late 1990s underscores the radical changes that have occurred since the early history of video art. The early works are single-channel (meaning one video image), as often in black and white as in color, and intended for viewing on a television or video monitor. Recent video installations, on the other hand, use multiple simultaneous projections of wall-sized moving images to create a whole environment, somewhat like entering into the video space itself.

While playing up these differences, I hoped that bringing classic and recent work together would underscore the formal, conceptual, and thematic continuities that give the medium its distinct and coherent identity. Titled *Outer and Inner Space,* the exhibition and book bring together some forty works that address the complex and shifting relationship between external

reality and interior states of mind. I chose Pipilotti Rist's *Sip My Ocean,* Shirin Neshat's *Rapture,* and Jane & Louise Wilson's *Stasi City* as three of the defining works of the late 1990s, the period of video installation's ascendancy. Combining formal innovation, technical sophistication, and deeply engaging experiences, these examples also stand among these artists' best works and are the ones by which their reputations were firmly established. In separate sections of the three-part exhibition and book, each of these works is paired with a selection of early works by other artists. This is intended to foster "conversations" among works that explore variations on the overall theme of outer and inner space, as well as to highlight the younger artists' awareness of aims and means shared with their predecessors.

This exhibition would not have been possible without The Emily Hall Tremaine Exhibition Award. I am fortunate that my exhibition plans meshed with the mission of the Tremaine Foundation to support "thematic exhibitions that put the works of contemporary art and/or architecture in a new or unconventional aesthetic, historical, cultural, and/or social framework." I am also grateful to our other patrons and benefactors, including The Council of the Virginia Museum of Fine Arts, the Fabergé Ball Endowment, Marion Boulton Stroud, the Friends of Art of the Virginia Museum of Fine Arts, The Horace W. Goldsmith Foundation, Mr. and Mrs. T. Fleetwood Garner through The Community Foundation, Bill and Sara Borowy, LaDifférence, and Zenith Electronics Corporation.

For lending *Sip My Ocean,* thanks are due to the Museum of Contemporary Art in Chicago, especially Elizabeth Smith, Jude Palmese, and Lela Hersh. I am grateful to Pipilotti Rist for her support of the loan and to Käthe Walser for technical guidance. Thanks, also, to Lawrence Luhring, Katy Schubert, Claudia Altman-Siegel, and Michele Maccarone at Luhring Augustine in New York and to Claudia Friedli at Galerie Hauser & Wirth in Zurich. For the loan of *Rapture,* I am grateful to Shirin Neshat and the Barbara Gladstone Gallery in New York, especially Mark Hughes, Costanza Mazzonis, Carter Mull, and Lodovica Busiri

Vici; and to Don Patrick for technical guidance. For the loan of *Stasi City*, I extend my appreciation to Jane & Louise Wilson and 303 Gallery in New York, especially Lisa Spellman, Walter Cassidy, and Mari Spirito. Special thanks are due to Sue MacDiarmid for technical guidance. Pipilotti Rist, Shirin Neshat, and Jane & Louise Wilson deserve additional appreciation for sharing their time and experience during the planning of this book and exhibition.

The single-channel works have come from five distributors: Electronic Arts Intermix in New York; The Kitchen in New York; Video Data Bank in Chicago; Vtape in Toronto; and Montevideo in Amsterdam. The staff of Electronic Arts Intermix deserves special mention, in particular Lori Zippay, John Thomson, Rebecca Clemen, Bob Beck, and Lauren Cornell.

Guest authors Laura Cottingham, Jonathan Knight Crary, and Eleanor Heartney have added immeasurably to this book, and to them I extend sincere thanks. At the Virginia Museum of Fine Arts, there has been tremendous support for this project. In particular, I want to recognize Michael Brand, Director; Carol Amato, Chief Operating Officer; Richard Woodward, Senior Associate Director; Joseph M. Dye III, Curatorial Chair; Kathleen Schrader, Associate Director for Exhibitions and Collections Management; Carol Moon, Director of Exhibition Planning; Monica Rumsey, Project Editor; Anne Adkins, Editorial Assistant and Indexer; Rosalie West, Senior Editor; Jean Kane, Book Designer; Sarah Lavicka, Chief Graphic Designer; Sara Johnson-Ward, Publications Assistant Manager for Sales and Marketing; David Noyes, Director of Exhibition Design and Production; Mary Brogan, Exhibition Lighting Designer and Exhibition Technical Manager; Kenneth Pinkney, Audiovisual Supervisor; and Ruth Twiggs, Manager, Media Production. Many others also gave their assistance: in Development, Pete Wagner, Elizabeth Lowsley-Williams, and Sharon Casale; in the Museum Library, Suzanne Freeman and Rebecca Dobyns; in Collections, Connie Morris; in Registration, Lisa Hancock and Susan Turbeville; in Education and Outreach, Sandy Rusak, Alfredo Franco, and Ron Epps; in Marketing and Public Relations, Michael Smith and Suzanne Hall; in Membership, Margaret Wade; and my departmental colleague Tosha Grantham.

Beyond the Museum, I owe a special debt of thanks to Andrea Miller-Keller for her enthusiastic support of this exhibition. Numerous other colleagues also provided valuable assistance, including Nicholas Baume, Wendy Clarke, Lisa Corrin, Molly Dougherty, Marilys Downey, Trevor Fairbrother, Tim Farrow, Kathleen Forde, Jonathan Geldzahler, Jill Hartz, Richard Herskowitz, Chrissie Iles, Ellen Napier, Kira Perov, James Rondeau, Michael Rush, Ella Schaap, Rob Storr, Waqas Wajahat, and Paige West. In addition, I benefited from my contact with many of the artists in the exhibition, including Klaus vom Bruch, James Byrne, Peter Campus, Cecelia Condit, Dan Graham, Chip Lord, Paul McCarthy, Branda Miller, Charlemagne Palestine, Howardena Pindell, and Jud Yalkut. I am also grateful to the Acadia Summer Arts Program, Mt. Desert Island, Maine, where in August 2000 I finished the Tremaine Foundation grant application and in August 2001 drafted the Introduction and Preface to this book. A special appreciation goes to Virginia Pye and to Eva and Daniel for their patience and goodwill during the entire course of this project.

John B. Ravenal
Curator of Modern and Contemporary Art
Virginia Museum of Fine Arts

John Ravenal

Introduction

Coming at a time when video is established internationally as a major art form, this book and the exhibition that it accompanies can perhaps skip over questions about the medium's validity that dogged its early practitioners, and instead move on to explore the cross-generational, thematic approach that brings together more than 40 early and recent works. It seems necessary, however, to acknowledge that, even after three decades of exhibition history, video art continues to present difficulties for many museum visitors. To a large extent, the challenge of video art stems from its format and reflects its early struggle to distinguish itself from the other media that made its birth possible, in particular television and film. Well into the 1980s, the video monitor defined the medium's physical appearance, whether as a solo box or as part of an installation, and whether showing pre-recorded tapes or live, closed-circuit feedback. The video monitor's resemblance to the household television set (it is essentially the same unit), might put some museum visitors at ease with its domestic associations; for others, however, its presence can confuse, suggesting perhaps that it is merely an educational adjunct to the real art. And for still others who come to the museum to engage with objects removed from the "degraded" realm of popular culture, the video monitor stands as an unwelcome intrusion, representing all that is antithetical to fine art.

Video art introduces a further difficulty for a museum audience—it requires a temporal shift in usual viewing patterns. Visitors can take as much or as little time as they wish to see paintings, sculpture, and other static arts; while sustained looking usually yields deeper insight, a cursory look offers at least the illusion of fully grasping the work's appearance (this is truer for two-dimensional works than for three-dimensional ones). Video presents a different model of spectatorship. As a time-based medium, it thwarts the viewer's all-embracing glance and control of time. Visitors can choose to watch the video's entire linear sequence or choose not to watch at all. But they do not have the option of exploring the image part by part, layer by layer, at their own pace, as they do with the fixed image or object. Video unfolds at the artist's discretion. Moreover, in front of static works, the viewer functions as a kind

of performer, moving forward, backward, or around as part of the looking process. The monitor, by contrast, has generally called for a stationary viewer while it presents its movements over time (this is truer for single-channel video, however, than for multiple-monitor installations).

Video projection came to replace the monitor as the central means of display in public settings over the course of the 1990s. Projection first appeared near the beginning of video art's history in the early 1970s, most notably in installations by Peter Campus and Keith Sonnier, but in low-resolution formats that have been described as "not only prohibitively expensive, but ludicrously unfaithful to the transmitted image."[1] In the early 1980s, Nam June Paik began using video projection combined with lasers and sculptural forms to push the medium forward. By the late 1980s, improvements in projection technology gave this method a decisive edge over monitors. In addition, a new generation of artists embraced the high production values of cinema, often using film and video in combination. Shirin Neshat and Jane & Louise Wilson shoot in 16mm film and then transfer to video to make their installations, a practice shared by Doug Aitken, Steve McQueen, and William Kentridge, among many others. Since the early 1990s, pioneering video artist Bill Viola has used a specialized high-speed 35mm film camera to make his extreme slow-motion video installations.

Large-scale, high-definition video projection offers the means to make enveloping spectacles of moving light and sound, especially when using multiple simultaneous projections. For many artists, this embrace of a cinematic aesthetic replaces the alternative aspirations of early single-channel video. In the 1960s and 1970s, video art emerged parallel to, and sometimes as an important part of, Conceptual Art and the related practices of Performance Art and Process Art. Video art also often reflected those movements' de-emphasis of the finished object in favor of direct expression of the original idea or working processes. As a new medium at the margins of mainstream art, video art thrived on the freedom to experiment inherent in its cutting edge position. Video wore its limitations—including black-and-white picture, low resolution, crude

or no editing, and low market value—as badges of its radical perspective. The sophistication and visual power of recent projected video, on the other hand, has allowed it to break out of the box of the monitor and more effectively compete with other media for the attention of viewers and collectors.

During the 1990s, projection-based video installations became omnipresent and sometimes omnipotent on the circuit of contemporary *internationals, biennials,* and other major exhibitions. At the 1992 *Documenta IX* in Kassel, Germany, video art in general took a more prominent place than ever before, and projections by Stan Douglas, Tony Oursler, and Bill Viola made some of the most memorable contributions. Video installations have won top awards in the past three Venice *Biennales* (Pipilotti Rist in 1997, Doug Aitken and Shirin Neshat in 1999, Pierre Huyghe and Janet Cardiff & George Bures Miller in 2001). Four of the six finalists for the Guggenheim Museum's 1998 Hugo Boss Prize were video installation artists, and one of them, Douglas Gordon, won the award. Three of the last five Turner Prizes, the prestigious award given to a young British artist by London's Tate Gallery, have been awarded for video projections (Douglas Gordon in 1996, Gillian Wearing in 1997, and Steve McQueen in 1999). William Kentridge's handmade animated films, which he shows as video projections, received the top award at Pittsburgh's 1999 *Carnegie International.* Paul Pfeiffer's tiny projected videos received the newly established Bucksbaum Prize at the 1999 *Biennal Exhibition* at the Whitney Museum of American Art. By the end of the decade, video art had not only joined the visual art mainstream but had become one of its central forms. In fact, consensus about the 2001 *Venice Biennale,* which was still on view as this book went to press, held that projected video installations overpowered the show— too many darkened rooms with moving images, more time-based work than a viewer could possibly take in.

For many viewers confronting these installations of projected light and sound, the question becomes, "Why is this not just cinema without seats?" Having conclusively distanced itself from television, video as projection then veered toward that other primary influence, film, borrowing some of its thunder and maintaining somewhat less critical distance than early video art did from television. Nonetheless, projection-based video installations do differ markedly from film. There are numerous historical, technical, and formal distinctions between the two media related to how they record and display information. Similarly, distinct visual languages for framing and presenting time and space have grown up around them. The difference most relevant for this exhibition and book, however, concerns the viewing experience.

Traditionally, film has aimed to transport the audience into its fictional realm, resulting in a kind of transparency of the medium (regardless of the stamp of a strong director). Many video installations, on the other hand, draw attention to the viewer as being external to the imagery, thereby raising issues of perception, observation, and spectatorship. Unlike film's stationary audience, viewers of projected video installations are often active participants who move through the surrounding space. The heightened awareness of the conditions of spectatorship often becomes, in some ways, the subject of the work. Rist's *Sip My Ocean* may entrance and seduce like film or commercial television, but it also resists easy consumption by the viewer's gaze as the artist irreverently stares back. Neshat's *Rapture* places the viewer in a space between two projections on opposite walls, across which groups of men and women take turns silently watching each other perform rituals and spontaneous actions. The viewer is both watcher and watched, as much subject as object. The Wilsons' *Stasi City* suggests that viewers—in constant motion to keep track of the four projections surrounding them on all sides—are both all-seeing eyes and themselves the objects of surveillance.

Although not predicated on a physically active viewer, like projected video installations, much early single-channel work also takes the role of the observer as a central subject. In *Theme Song,* Vito Acconci directly addresses his viewers, even questioning their existence. Joan Jonas's *Vertical Roll* fractures the coherent fictional space that viewers are conditioned to expect from television, thus encouraging viewers to reflect back on their role as observers. Bruce Nauman's repetitive performance in *Slow Angle Walk (Beckett*

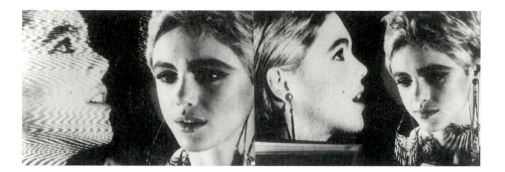

Andy Warhol
Outer and Inner Space, 1965
film stills

Walk), as arduous to watch as it was to perform, induces a tension and boredom that, he hoped, might align the viewer's conditions of reception with the artist's own conditions of production. These works and many others actively explore the viewer's identity, the relationship between artist and viewer, and the question of whether anyone is even watching. Early video art focused on the conditions of viewing as one primary way to signal its difference from television. In the 1960s and 1970s, television came to be seen by many artists and intellectuals as an apparatus of state control, a commercially driven force using the guise of entertainment to reinforce gender and class roles and other norms of dominant culture, all to produce a homogenous society of complacent consumers.

Once artists gained access to video, they seemed to have in their hands the ideal means of subversion, using the master's tools against himself (although only rarely did artists actually have access to broadcast-quality equipment or television airtime). Some younger viewers of this exhibition and readers of this book might find it difficult to recognize the urgency behind these early works. These videos can appear dated—in technology, in dress, in attitude—and thus can be seen as period pieces. Other viewers, however, especially those who experienced the 1960s and 1970s, will recognize the desire to loosen the straightjacket of social conformity. The intensity of feminist critiques, anti-Vietnam War statements, new attitudes about sexuality, political activism, and radical experimentation that together informed an anti-establishment perspective might, for this audience, evoke the same reactions— pro or con—that they did some three decades ago.

The theme of "outer and inner space" that unifies the works featured in this exhibition and book grows directly out of video art's longstanding preoccupation with the conditions of spectatorship. The title derives from Andy Warhol's 1965 film of the same name, *Outer and Inner Space,* his only work combining video and film and his first double-screen film.[2] This work features two side-by-side views of Warhol's charming star, Edie Sedgwick, seated beside a monitor showing videos of herself that Warhol had made previously using an early portable camera.[3] In each of the two screens, Sedgwick appears in profile on the monitor and facing forward in the "live" film image, resulting in four simultaneous portraits. Engaging with an unseen person off-screen and to one side of the camera, the live Sedgwick talks nonstop, except to draw on another cigarette, sip a drink, and make faces in response to what she hears herself say on the monitor.

An innovator in so many areas of his work, Warhol here anticipated future developments in film and video, including his use of the two media video and film in the same piece, the split-screen format, and electronic manipulation of the video image. But most relevant to the subject at hand, Warhol's video-film provides a brilliant media art precedent for considering the relationship between outside and inside, surface and depth, outer appearance and inner awareness. This exhibition and book are intended to prompt an expanded meditation on the implications of outer and inner space. The goal is to bring early and recent video art together to illuminate shared aesthetic, psychological, and philosophical issues. These include subject and object, illusion and reality, public and private, and mind and body in relation to space and time. Altogether, these works suggest the broad capacity of the video medium for simultaneously reflecting its own inner workings and the world around it. ∎

1. Peter Frank, "Video Art Installations: The Telenvironment," in *Video Art: An Anthology,* ed. Ira Schneider and Beryl Korot, (New York and London: Harcourt Brace Jovanovich, 1970), 204. the history of projection is beginning to be explored; for example, see the exhibition catalogue *Into the Light: The Projected Image in American Art, 1964–1977* (New York: Whitney Museum of American Art, 2001), curated by Chrissie Iles. This show (October 18, 2001–January 6, 2002) reconstructed a number of classic works in film, video, and slide installation.

2. Note that in the Film-makers' *Cooperative Catalogue,* No. 4 (New York: Film-makers' Distribution Center, 1967), Gerard Malanga, Warhol's Factory assistant, describes it as a single-screen work, one reel shown after the other for 70 minutes, and dates it 1966.

In her program notes for an exhibition at the Whitney Museum of American Art, 1998, Calle Angel (author of a forthcoming catalogue raisonné of Warhol films), dates the Warhol film to August 1965 and calls it his first double-screen film at 33 minutes. And J. Hoberman notes that an advertisement for its first screening at Manhattan's Filmmaker's Cinémathèque in the January 27, 1966, issue of The Village Voice promised a double-screen showing (*New York Times,* Sunday, November 22, 1998, 34.)

3. Warhol used a prototype slant-scan Norelco camera and recorder, lent to him for one month by *Tape Recording* magazine (see Angel, footnote 2). The short-lived Norelco preceded the Sony Portapak which Nam June Paik used several months later to make what are usually considered the first independent artist's videotapes.

Laura Cottingham

and everyday life during the 1960s was centered in the three nations that emerged as economically dominant during the years following World War II: Japan, Germany, and the United States. These three nations continue to lead the technological developments in video as an electronic medium, and remain crucial, although not exclusive, centers for video's production and exhibition, commercially as well as artistically.[2]

Origin & Relation to Film

Video as an electronic recording and transmission device has existed since the birth of the television era. Linguistically, its name is derived from the Latin verb *videre,* "to see": *video* means "I see." Technically, video developed out of combined interests, commercial and military, to record and transmit sight and sound at less expense, greater speed, and higher quality than was initially possible at the beginning of broadcast technology during the 1920s, when, for instance, it was hoped that 35mm film newsreels would be regularly transmitted into theaters across the United States by telephone wires.[3]

The magnetic basis of video differentiates it synthetically and visually from film. Technically, video's relationship to the film family is that of the adopted child: video shares no material constituents with its photography and film relatives and even *looks* different.[4] Artistically, however, video is film's legitimate heir. Film, like video, was developed for commercial purposes; its artistic potential was seized when artists gained access to the equipment developed by Thomas Edison and film's other business-minded inventors. During the 1920s especially, film underwent a serious artistic development. In the Soviet Union, Sergei Eisenstein dramatically expanded the visual vocabulary of the new sound picture and championed film as the ultimate art form; while in France, Surrealists such as Luis Buñuel, Salvador Dali, and Jean Cocteau brought film— previously dismissed as mere documentary or mere entertainment—firmly into fine art discourse.

In the United States, it has, since the beginning, been difficult to impossible to sustain an artistic commitment within the commercial basis of the Hollywood film system. Indeed, the United States

New Wine into Old Bottles: Some Comments on the Early Years of Art Video

by Laura Cottingham

More than a few mythologies and histories of early video already exist. Since video is in many respects a more literary medium than other twentieth-century art forms, its practitioners have tended to put their ideas on paper more conscientiously than have visual artists in other fields.[1] This is especially true of the first generation, those active in production from around 1965 to 1975, who had a heightened sense of the importance of their attempts to transform into art what most people simply call television. The motivations and professional backgrounds of video's first practitioners were incredibly diverse, which must also account for the relatively high amount of textual documentation: first-generation video makers were not only arguing their case against more traditional art media, attitudes, and aesthetics; they were also engaged in internal debates to establish criteria by which the new video medium should be judged.

For those already acquainted with the central myths of video's absorption into fine art discourse, many of my observations will no doubt be redundant. What I have tried to do is synthesize some of the dominant currents of independent video's early movements, from the perspective of one who arrived on the scene— as a critic, curator, activist, and video maker—after two decades of groundwork had already been laid by others. Although my remarks are primarily centered on video's development in the United States, it should be noted that the expansion of video production into art

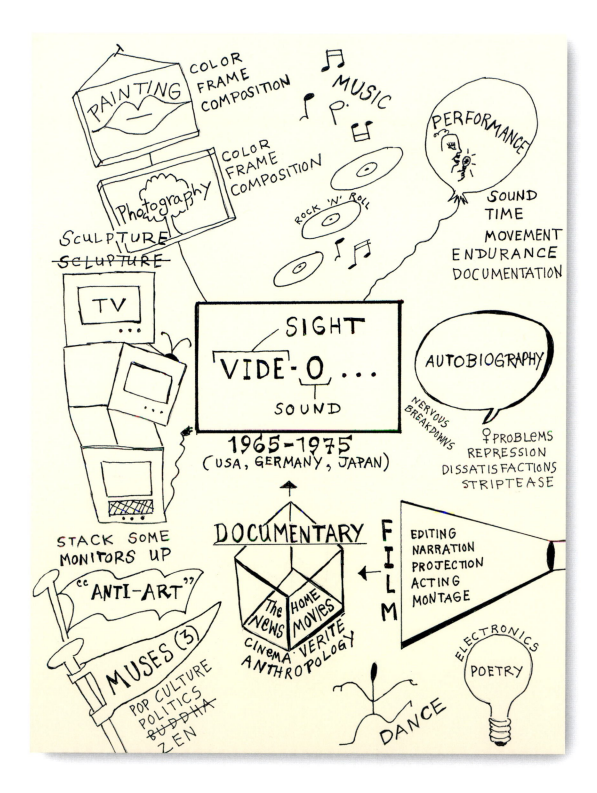

Laura Cottingham, *After Alfred Barr: Video Art,* 2001, ink on paper, 12 x 14 inches
(illustration drawn by the author to diagram the early history of video art)

continues to occupy the ironic position of having the most technological resources—for both film and video—of any economically developed nation while maintaining the lowest interest in artistic or cultural production.[5] This dramatic contradiction underlies the entire history of independent film and video in the United States.

During the 1940s, a deliberately anti-Hollywood approach to film began to emerge in the United States with the work of Maya Deren, who pioneered new approaches to nonfiction film and continued to explore the cinematic vernacular as suggested by the Surrealists. By the mid-1960s, the "New American Cinema" constituted a self-recognized movement, and included practitioners as artistically diverse as Shirley Clarke, Kenneth Anger, Marie Menken, Jack Smith, Andy Warhol, and a vast coterie of other New York independent filmmakers who also worked in Super 8 or 16mm, championed the "Home Movie," and were organized around the critic, film maker, and activist Jonas Mekas. A passage of Mekas's 1966 commencement address to the Philadelphia College of Art synthesizes the implicit defensiveness of the American art filmmaker, that castaway in the big blue sea of Hollywood expectations:

> You may be wondering, sometimes, why we keep making little movies, underground movies, why we are talking about Home Movies, and you hope, sometimes, that all this will change soon. Wait, you say, until they begin making big movies. But we say, "No, there is a misunderstanding here. We *are* making real movies." [6]

American independent film and video makers have consistently reckoned with the discrepancy between their lack of access to the highest level of equipment—while at the same time screening their works to a public whose eyes have been trained on the most expensive and technically flawless feature films and automobile commercials in the world. While the New American cinéastes of the 1960s found themselves forever explaining why their movies didn't "look as good" as Hollywood productions, the first generation of video makers were forever explaining why their tapes didn't "look as good" as broadcast television.[7]

Les Levine began making videos in the mid-1960s with works such as *Bum* (1965), an in-camera edited documentary of residents of New York's Bowery. In "One-Gun Video Art," a significant essay on early video's parameters and possibilities, Levine adopts for video the role of explicator that Mekas held for independent cinema—albeit with an even crankier tone:

> The art viewer is always asking, why can't video artists make their video tape like real TV? The first answer is simply they don't want to. They are trying to use TV to express art ideas instead of simply to sell products, the most common use of broadcast television. . . . As a matter of fact, broadcast TV has not had a new idea in years. But they have learned how to produce rubbish with amazing style and production. This glossy, technical style prevents the audience from seeing that everything on TV is a rerun of everything else on TV.[8]

When consumer access to low-budget video technology arrived in the mid-1960s, many already established independent filmmakers reacted with horror: reel-to-reel video offered even worse visual and sound quality than the low-budget film stock they were already working with (and couldn't even capture color). Many independent filmmakers initially refused video as inferior to film; while others jumped at the chance to work with the newly available medium, reveling in, rather than decrying, its difference from film. For instance, Shirley Clarke, active in film in New York during the 1950s and 1960s and known for documentary and art features such as *The Connection* (1961), leaped at the opportunity to inexpensively and easily record live events that could potentially be broadcast on television. While other cinéastes saw only the imperfections of early video—its grainy picture, poor sound quality, and limited camera range—Shirley Clarke saw the future. In 1971 Clarke formed the Teepee Videospace Troupe (also known as T. P. Video Space Troupe), a loose collaboration of members of the downtown New York avant-garde film and theater communities. Clarke carried her video camera everywhere, documenting the political, social, artistic, and daily activities of her friends. The relative portability of the equipment made it possible for her to capture

serendipitous personal and social encounters, including
a party at the weekend home of John Lennon and Yoko
Ono's agent in upstate New York, Allen Ginsberg on a
bus, and a picnic on the roof of Manhattan's infamous
Chelsea Hotel. Some of Clarke's Teepee Videospace
Troupe tapes, like those of other early avant garde and
activist video makers, were aired on local public-access
cable channels.

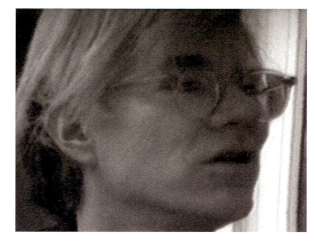

Shirley Clarke
Teepee Videospace Troupe Tapes:
The First Years, 1970–73, video still

1965: The Portapak Revolution

In 1965 the introduction of the Sony Portapak, a basic
video camera and recording package, made it possible
to "make television" for significantly less than the cost
of previous video recording devices (such as those
employed by commercial television stations). Many
artists were attracted to the "natural" look of recordings
made on the Portapak equipment, precisely *because* of
its lack of resemblance to either broadcast television or
Hollywood film. Early half-inch, reel-to-reel, black-and-
white recordings brought with them a sense of immedi-
acy that reflected the technical limitations, as well as
the advantages, of video (as opposed to film). These
differences include greater sensitivity to minimal light-
ing conditions; the fact that the camera's limitations
forced the necessity of close-ups; the synchronization
of picture and sound; the portability of the camera; the
reliance on the zoom lens, rather than on long shots or
camera pans; the capacity for instant replay; and the
then-inherent editing restrictions. The implicit features
of early video produced an aesthetic of intimacy and a
sense of candidness or lack of manipulation: it looked
more "real"—that is, less slick and manufactured than
the standards then current for broadcast television and
mainstream movies.[9]

Video was the medium of choice for the *artistes
refusés* of the Woodstock generation. It appealed to
those in disdain of the decorative and elitist traditions
of painting and sculpture; provided a new site for con-
ceptual, rather than object-based, investigations;
offered the hope of mass democratic dissemination into
living rooms; allowed for the introduction of autobiog-
raphy, literal ideas, and narrative into the work of art—
and it was "new." Marshall McLuhan, the most influen-

tial prophet of television's democratic potential, was
their primary guru. McLuhan's *Understanding Media* (1967)
functioned as a bible of critical platitudes and optimistic
mantras for 1960s video makers who otherwise shared
few or no common intentions other than an agreement
that "the medium is the message." In the context of
understanding the period within which video art emerged,
neither the mythology of television created by McLuhan
nor the promises of social transformation—produced
out of the student mobilizations, anti-war and civil rights
protests, and gay rights and women's liberation move-
ments—can be underestimated. Arriving as it did on the
cusp of 1968, video looked like part of the revolution.

Video & Anti-Television

A dominant current of the first wave of video practice
was aggressively anti-television and "anti-art." It wasn't
until the 1970s, nearly a decade into the Portapak rev-
olution, that a clear distinction between "art video"
and "activist video" began to emerge. From the onset,
artists and collaboratives such as Les Levine, Martha
Rosler, Allan Sekula, The L.O.V.E Collective, Nancy
Buchanan, Mako Idemitsu, Ant Farm, The Los Angeles
Women's Building, Douglas Davis, T. R. Uthco, Suzanne
Lacy, Raindance, Ardele Lister, TVTV, and others brought
a deliberately political relationship to video's produc-
tion and reception. Some of these "artists" (there was
a healthy disdain for this term as an elitist moniker,
even among some who worked within the art network
of galleries, art schools, and museums) also worked in
activist video—that is, in the production of usually
documentary-style tapes intended for public-access
television and/or educational distribution.

The alternative television movement—a
fledgling network of grass-roots, community-based,
mostly-documentary independents—made serious, if
futile, attempts to infiltrate America's airwaves during

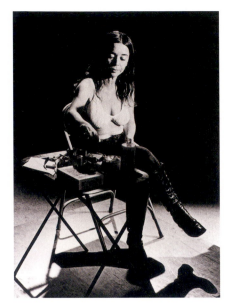

Eleanor Antin
Representational Painting, 1971, production still

structure, much of the earliest works by women in video is involved with explorations of female subjectivity and subjugation. Indeed, video is the first art media that women entered on the ground floor. In the essay accompanying the 1993 exhibition *The First Generation: Women and Video, 1970–75,* curator JoAnn Hanley observed that, "Without the burdens of tradition linked with the other media, women video artists were freer to concentrate on process, often using video to explore the body and the self through the genres of history, autobiography, and examinations of gender identity. Women also used the new medium to create social and political analyses of the myths and facts of patriarchal culture, revealing the socioeconomic realities and political ideologies that dominated everyday life."[11]

In Eleanor Antin's *Representational Painting* (1971), while spending most of the video mis-applying makeup (paint) to her face, the artist combines a conceptual exploration of the limits of video's documentary capacity as a mirroring device with a critique of both painting and women's social position as a decorative object. In *Vital Statistics of a Citizen, Simply Obtained* (1977), Martha Rosler features herself as a specimen measured and analyzed by a white man in a doctor's coat, while a voice-over catalogues instances of political oppression against women. Some works—such as Nancy Angelo and Candace Compton's *Nun and Deviant* (1976) and Eleanor Antin's *The Adventures of a Nurse* (1976) and *The King* (1979)—sought to challenge images of female stereotypes. Other tapes, such as Suzanne Lacy's *Where the Meat Comes From* (1976), Nancy Buchanan's *These Creatures* (1979), and Cynthia Maugham's *Untitled (Domestic Violence Revenge)* (1976) made explicit—through metaphor, wit, and irony— prevailing cultural prejudices and violence against women. Sexual abuse, rape, eating disorders, unfair marriage and divorce laws, restrictions against female autonomy in employment and sexuality, the lack of representation of women in government, the political divisions between white and black women—the same issues that emerged in the women's liberation movement during the 1970s—became content and material for artists working in video. Much of the work produced

the early years of cable television. While most art video was produced and circulated in New York or California (especially Southern California and San Francisco), the activist video movement was more regionally diverse, and was organized to address social issues and communities—nonwhites, women, gay men and lesbians, the rural and urban poor—whose images and concerns were the most subject to neglect, manipulation, and vilification by broadcast television.[10]

The Los Angeles Woman's Building, a center for feminist and art activities in Southern California during the 1970s, featured one of the first independent video production and training facilities, founded by Lynn Blumenthal and Kate Horsfield. The video and performance artists who produced or exhibited within the context of The Los Angeles Woman's Building during the seventies included Nancy Angelo, Eleanor Antin, Nancy Buchanan, Candace Compton, Mako Idemitsu, Cynthia Maugham, Susan Mogul, Ulrike Rosenbach, Rachel Rosenthal, Martha Rosler, Ilene Segalove, Barbara Smith, Janice Tanaka, and The Waitresses, among others. Additionally, Woman's Building members produced collaborative public performances that were staged to attract—and be broadcast by—local television. These made-for-television public consciousness-raising events included the 1976 three-week collaborative series of performances devoted to raising awareness about rape, *In Mourning and in Rage* (1976), by Leslie Labowitz and Suzanne Lacy.

Since the first decade of art video dovetailed with the women's liberation movement and the consequent emergence of women into the gallery and museum

by women during the 1970s is consciously autobiographical, as feminists sought to mine their own lives for personal examples of why political and social change was necessary. In Howardena Pindell's *Free, White and 21* (1980), the artist intercuts first-person testimony of racist and sexist events in her life with footage of herself in white-face, usurping what she expects will be the standard white person's indignant response to her complaints. Pindell's "white woman" persona responds to her autobiographical accounts with lines like: "After all we've done for you!" and "If you don't do what we tell you to do, we'll find other tokens."

The critical mood against mainstream commercial media and conservative social values was so pervasive that even artists unaffiliated with any of the community-based political movements of the period produced anti-television propaganda tapes during the 1970s, including Richard Serra's *Television Delivers People* (1973) and Chris Burden's *Do You Believe in Television* (1976), which are styled as commercials.

In acknowledgment of the then-current hope that artists could infiltrate *some kind* of television—either public access, cable, public broadcasting, or even network—early video art was sometimes even referred to as "artists' television." Curator David Ross, one of video's most active early institutional supporters in the United States, had high hopes for art's access to television in 1977: "It is obvious that the idea of social or semi-theatrical video screenings in the museum galleries adequately serve the needs of the art world. But these insular screenings cannot replace the need to reach a potentially wider audience in the normative TV context: the home. . . . We must continue our efforts to make broader use of broadcast and cable TV in a continuing attempt to make the issue of contemporary art available to a wider public."[12]

Video & Broadcast Television

But network television not only provided video artists with a point of resistance: it also supplied them with inspiration and material. Standard American broadcast television formats—the game show, the news, the talk show, the cooking show, the commercial, the sitcom,

the family drama—were appropriated, reenacted, and satirized. This tendency to reference mass culture appears especially pronounced during the 1970s, coming after video's initial primary usage as a documentary tool to record live public events, private studio performances, and technical explorations. In 1976, Los Angeles artist Ilene Segalove had a license plate on her car that read "TV is OK." Segalove's *TV is OK* (1976) recounts her conversations with passersby who wanted to know what her license plate really meant. An earlier Segalove tape, *Advice from Mom* (1973), draws on television's fixation on constructing American identity through consumerism: a mock *Life Styles of the Rich and Famous,* it features a house tour with Segalove's mother acting as a personal shopper who knows where and for what price to buy whatever you might need.

William Wegman's earliest collaborations with his first dog, Man Ray—the short works from 1970 to 1973—are also indebted to the art of salesmanship, arguably the most advanced art form in the United States. Wegman's comic style relies on the hyperbolic rhetoric of television gadget salesmen and the sight gags of Charlie Chaplin and the Marx Brothers. In *New and Used Car Salesman* (1973–74), Wegman plays the ultimate salesman, even pulling Man Ray onto his lap in a pathetic attempt to use the dog to prove the sincerity of his ridiculous sales claims. Martha Rosler's *Semiotics of the Kitchen* (1976) is a satirical mockery of a television cooking show with a feminist bite: her

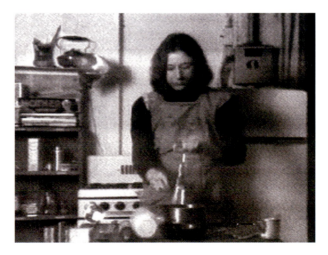

Martha Rosler
Semiotics of the Kitchen, 1975, video still

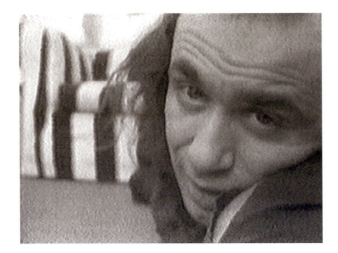

Vito Acconici
Theme Song, 1973, video still

Julia Child cuts the air, rather than *le poulet,* with a knife. Susan Mogul's *Dressing Up* (1973), which features the artist explaining the department store origin and sale prices of various pieces of her personal clothing, is a kind of personal anti-commercial for shopping, and yet another work indebted to American stand-up comedy. Mike Smith's *Down in the Rec Room* (1979) presents a sly suburban "white boy" adolescence saturated in popular television and pop music.

Even the early performance-based tapes by Vito Acconci, which often include long monologues, could be said to rely on mainstream film and television precedents, to the extent that the artist is "acting." With their autobiographical references, closely cropped framing, and direct address to the audience, these performances are intended, of course, to be "more real" than their broadcast sitcom counterparts—but they are enacted before a camera and Acconci *is* "acting." *Theme Song* (1973) is one of his best works from the 1970s. Here, he makes explicit the manipulation implicit in his self-presentations as he attempts to seduce his (assumed female) audience while talking along with and back to lines taken from songs by Bob Dylan, The Doors, Van Morrison, and Kris Kristofferson playing on his portable audiocassette player. Although the first-generation video makers were almost unanimously *against* mainstream television, they were also deeply saturated in it and, perhaps, also incredibly in awe of it.

One of the most ambitious videotapes, technically and artistically, produced during the 1970s featured at its core one of the most dramatic moments in twentieth-century politics and television: the 1963 assassination of President John F. Kennedy. A collabora-

tion between two San Francisco video collectives, T. R. Uthco (Doug Hall, Diane Andrews Hall, Jody Proctor) and Ant Farm (Chip Lord, Doug Michels, Curtis Schreier), *The Eternal Frame* (1975) takes as its point of departure a few frames of the internationally recognized assassination footage that was recorded on Super 8mm film by Abraham Zapruder, a bystander. On Dealy Plaza in Dallas, Texas, the artists re-staged the assassination in 1975, with Doug Hall performing the role of President Kennedy and Doug Michels playing the part of his wife, Jackie. Their costumes, makeup, Cadillac, and gunshot were so convincingly offered that a spectator to the reenactment cried. Indeed, as *The Eternal Frame* crosscuts between the real assasination and the fake one, the viewer is confounded to distinguish between them, especially because the original camera position was also successfully duplicated by the artists. In addition to the technical virtuosity of the reenactment, the artists added further to the social and artistic meaning of their simulacra. Hall calls himself the "Artist President," emphasizing the Kennedy era's distinct place within the television era, and delivering philosophical pronouncements such as, "I am nothing more than another image on your television screens. . . . I suffered my image death. . . . The media created me. No president can ever again be anything more than an image. . . ." Insightful witticisms provided by the T. R. Uthco and Ant Farm teams in both performative segments and behind-the-scenes documentary ("Texas is a scary place," says Michels, the man dressed as a woman to play Jackie in broad daylight in downtown Dallas) give the work an additional self-reflexive level. *The Eternal Frame* includes documentary footage of spectators responding to the Dallas reenactment as if it were a great moment of entertainment. It also shows audience members critiquing a rough cut of the piece after a screening in San Francisco, where one middle-aged white man angrily calls the work "forty minutes of phoniness," "very irresponsible," and "meaningless." The interplay between reality and the mythification of historical events—and the role television and spectatorship play in this construction—makes *The Eternal Frame* one of the most intelligent commentaries ever

Ant Farm & T. R. Uthco
The Eternal Frame, 1975, video still

made on the political role that the mass media play in contemporary American life.

The technical potential for "taking" images and sound from broadcast television was practically impossible with consumer-level equipment during the 1960s (at most, you could place the Portapak camera in front of a flickering television screen). But by the mid-to-late 1970s, more reliable means of recording directly from broadcast television became feasible, and more artists began to borrow, intercut, manipulate, and transform images taken from television. Dara Birnbaum's *Technology/Transformation: Wonder Woman* (1978–79) combines repetitive clips from the CBS series *Wonder Woman* with a disco soundtrack of the same title produced by The Wonderland Disco Band. James Byrne's *Works for Broadcast* (1977) crosscuts simple physical gestures by the artist—standing, crawling, looking—with television clips taken from commercials, the news, and old movie segments. Klaus vom Bruch's *Propellerband* (*Propeller Tape,* 1979) intercuts archival footage from a World War II American warplane with images of the artist's face, establishing a meditative metaphor between history and the present, the past and the individual.

In considering the relationship between art and television during the 1970s, it is worth remembering that Pop artist Andy Warhol spent the last ten years of his life trying to get his own television show. Warhol's own version of Shirley Clarke's *Teepee Videospace Troupe Tapes* was a talk-show format that featured his own friends. Aired on New York City cable access in the late 1970s, "Warhol's Fifteen Minutes" enjoyed a brief run on MTV in the early 1980s. Warhol's real goal, according to numerous entries in *The Diaries,* was to have his own

prime-time network talk show: a dream left unfulfilled at his death in 1987.[13] Warhol was the first prominent gallery artist to work with video. In 1965, using a Norelco video kit, he filmed *Outer and Inner Space,* featuring Edie Sedgwick chain smoking and talking (on a nearly inaudible, 16mm soundtrack) seated next to a video monitor that simultaneously projected her image. Like most Warhol films—which tend to be startlingly prescient in their understanding of what film *could* do, rather than being fully realized works—*Outer and Inner Space* captures an artistically innovative aspect of time-based media: video's unique capacity for instant, real-time replay.

Video & Performance Art
Video's instant-replay feature was also what led choreographer Merce Cunningham to place a monitor on the stage in 1965, offering a reproduction of dance simultaneous to its live performance—and originating a collaboration between video and dance that continues to this day. Dance and video enjoyed a special and inevitable mutual enthusiasm during video's early years: video offers dance the possibility of preservation and permanence, while dance offers video an art form that moves. During the 1970s, Merce Cunningham began to collaborate regularly with video maker Charles Atlas to produce video dance work such as *Blue Studio: Five Segments* (1975–76); Atlas has continued to work with Cunningham and other major choreographers in the subsequent decades. Other artists, such as Doris Chase, also explored the special technical advantages video could offer dance, not only as a recording device, but as a means through which the special attributes of

dance—of deliberate human movement—could be adjusted with time, color, kinetic patterns, and sound to produce new effects. For instance, Doris Chase's *Dance Eleven* (1974) features Joffrey Ballet dancer Cynthia Anderson performing a duet with a synthesized image of herself.

Art video emerged alongside and concurrent with other radical breaks with nineteenth-century European aesthetics that occurred in urban centers throughout the world during the 1960s, especially the emergence of Performance Art and "happenings." The history of the first generation of video art is coextensive with that of Performance Art: both constitute, like rock and roll, significant new artistic contributions from the generation of artists born just after World War II who came of age in the 1960s. Much of the most interesting work in video made between 1968 and 1978 can accurately be described as "a video of a performance." This is true of works such as Vito Acconci's *Claim Excerpts* (1971), which was performed in the basement of 93 Grand Street while simultaneously "broadcast" upstairs to the gallery; or the multitude of private studio performances from the first decade, such as Bruce Nauman's *Stamping in the Studio* (1968) and *Revolving Upside Down* (1969); Charlemagne Palestine's *Internal Tantrum* (1975); Susan Mogul's *Dressing Up* (1976); Paul McCarthy's *Black and White Tapes* (1970–75); Martha Rosler's *Semiotics of the Kitchen* (1975); and Howard Fried's *Fuck You, Purdue* (1971). Additionally, some works now classified as video works, such as Marina Abramović's collaborations with Ulay and Hannah Wilke's 1976 strip-tease performance behind Marcel Duchamp's *The Bride Stripped Bare by her Bachelors, Even* at the Philadelphia Museum of Art, are documentation of performances in public places. The video documentation of Wilke's performance is by Christof Stenzel; the performance itself is variously titled in earlier publications and on slides, but has, in the last two Wilke catalogues, been cited as *Through the Large Glass*. The video is cited as *C'est la Vie Rose* and credited to Stenzel in the latest (Perlis) catalogue on Wilke.

The technical limitations of early video inspired at least one aspect of its use as a recording device for performance: in particular, the severe limita-tions inherent in the earliest low-budget reel-to-reel editing systems and the lack of accessibility to better editing equipment encouraged many practitioners to use the camera to record an event or performance in real time, without the assumption that editing could or would occur later. Some works, such as Joan Jonas's *Good Night, Good Morning* (1976), deliberately use the camera as the editor. In *Good Night, Good Morning*, changes in scene and lighting occur because the artist recorded each "good night" and "good morning" between switches of the camera's off/on button.

Video—Looking Back, Looking Forward

Interestingly, some of the most influential members of the first generation of art video makers did not come to video through film or fine art. Vito Acconci was a writer, and Steina Vasulka and Nam June Paik were previously musicians. Although many visual artists working in New York during the late 1960s and early 1970s explored the newness of video and produced and exhibited tapes, a significant number of influential early art video practitioners did not continue working in video. This occurrence was predicted early on by one New York critic, the pseudonymous Mona da Vinci, who asserted that "Artists who are primarily painters or sculptors such as Dennis Oppenheim, Robert Morris, Lynda Benglis, and Richard Serra seem less likely to continue working in video as a totally self-contained art medium. As visual artists they sooner or later retreated back into the 'object,' used either in conjunction with their video tapes as part of an installation exhibit or as a separate and temporary experimental phase apart from the mainstream of their work."[14] The assumptions and demands of the physical architecture and artistic values of museum culture have often encouraged video to align itself, however absurdly and tangentially, with sculpture—beginning with Nam June Paik's monumental TV stacks and other video installations that incorporate sculptural components. Since the 1980s there has been a movement toward full-wall projections—and away from hoped-for television broadcasts and single-monitor presentations in galleries—that aligns video more closely to painting, especially because fewer artists today work with sync-sound than did the first generation, despite the technological advances.[15]

Other early art video practitioners, including Nam June Paik, Woody and Steina Vasulka, Ed Emshwiller, Mary Lucier, and Shigeko Kubota, were most interested in developing an electronic poetics of video. Paik's most well-known early work, *Global Groove* (1973), opens like a music video. Short interviews with his art contemporaries, including Allen Ginsberg, John Cage, and Paik's frequent collaborator, the cellist Charlotte Moorman, are overlaid with an audio track drawn from American popular music, including "Rock Around the Clock" and "Take Me Out to the Ball Game." Paik's technical play is developed from interruptions in the transmission signal to produce imagery that is wavy, abstract, psychedelic, and—as the title of *Global Groove* suggests—"groovy." The early videos made by Steina and Woody Vasulka are more "pure" in their technical play, as they rely exclusively on manipulations of the camera and the recording apparatus and don't invoke images or sounds from popular culture. In works such as *Solo For 3* (1974), which features three cameras focused on the number "3," producing a hologram effect, or in *Reminiscences* (1974), where magnetic manipulations create a series of yellow and purple waves that are in

fact the recording of a natural landscape, the Valsulkas are expanding the visual vocabulary of image recording while challenging the assumption that what a camera records is "real." Much of the first generation's work concerned itself with this type of investigation and critique. In Joan Jonas's *Vertical Roll* (1972), for instance, the narrative is continuously disrupted by the deliberate appearance of the vertical line that divides each "frame" (video recording was modeled after film). This "frame," usually hidden from a viewer's experience of video, is rendered apparent by Jonas as a way of reminding the audience that what you are watching is not, in fact, "real."

Although the technical and artistic foundation of art video was formed during the 1960s and 1970s, the medium is still in its infancy at the dawn of the twenty-first century. How video will continue to challenge our understanding of what art is or could be remains to be seen—and heard. ∎

Laura Cottingham is an art critic and video artist who lives in New York City. She is the author of Seeing Through the Seventies: Essays on Feminism and Art *(2000). Her videos include* Not For Sale: Feminism *and* Art in the USA during the 1970s *(1998), and, with Leslie Singer,* The Anita Pallenberg Story *(2000).*

1. See, for instance, Doug Hall and Sally Jo Fifer, eds., *Illuminating Video: An Essential Guide to Video Art* (New York: Aperture, in collaboration with The Bay Area Video Coalition, 1990).

2. Canada, so often neglected in the histories, also functioned as an important location for independent video's production and exhibition during the medium's initial emergence.

3. See, for instance, Albert Abramson, " Video Recording: 1922 to 1959," in *Video: Apparat/Medium, Kunst, Kultur; ein internationaler Reader,* ed. Siedfried Zielinski, (Frankfurt am Main: Peter Lang, 1992), 35–45.

4. The conversion from analog to digital video during the 1990s has significantly raised the quality standards for color brightness and saturation, sound, and picture clarity beyond what was initially possible in the first decades of video. Many of us, myself included, predict that film making will soon become obsolete as video technology moves increasingly toward closing the visual reproduction quality gap. Digital editing, more precise and economical than anything possible for film, is already the industry standard.

5. I am referring not only to the obvious lack of tax-financed cultural funding in the United States but also to the relative lack of an audience for art in the United States. It is demonstrably observable that American presidents and congressmen, like the population at large, prefer football games, talk shows, and beauty pageants to art of any kind.

6. Jonas Mekas, "Where Are We—The Underground," in *The New American Cinema: A Critical Anthology,* ed. Gregory Battcock (New York: E. P. Dutton, 1967), 20.

7. Some artists were given access to network television station studios, allowing them to work with color and various kinds of special effects before these capabilities were available on consumer-level equipment. For instance, Peter Campus collaborated with WGBH-TV, Boston; and Bill Viola produced numerous tapes with WNET/Thirteen, New York.

8. Les Levine, "One-Gun Video Art," in *New Artists Video: A Critical Anthology,* ed. Gregory Battcock (New York: E. P. Dutton, 1978), 89.

9. Indeed, by the late 1980s and early 1990s, standardized advances in video technology —color tape replaced black and white, nonlinear supplanted linear editing—produced a small sentimental backlash among a group of younger video makers when the Portapak aesthetic was no longer possible to produce from post-1980s consumer video recording devices (which were manufactured to shoot only in color, for instance). Artists such as Sadie Benning, Cecilia Dougherty and Leslie Singer began working with a Mattel toy Pixel vision camera in order to recapture the grainy, black-and-white "look" of the mid-to-late 1960s. See for instance, Sadie Benning's *It Wasn't Love,* 1992; Cecilia Dougherty and Leslie Singer's *Joe-Joe,*1993, and Leslie Singer's *Taking Back the Dolls,* 1994.

10. See for instance, Deidre Boyle, *Subject to Change: Guerrilla Television Revisited* (New York: Oxford University Press, 1997). Boyle documents the trials and tribulations of early grassroots and guerrilla television organizations, focusing on two community-based video organizations, University Community Video, Minneapolis, and Broadside Television, Whitesburg, Kentucky, as well as Top Value Television (TVTV), the most well-known of the funky video collections that burgeoned and then went bust during the 1970s.

11. JoAnn Hanley, *The First Generation: Women and Video, 1970–75,* exhibition catalogue (New York: Independent Curators Incorporated, 1993), 10.

12. David Ross, *Southland Video Anthology: 1976–77,* exhibition catalogue (Long Beach, California: Long Beach Museum of Art, 1977), 92.

13. It's safe to presume that Warhol would have continued to explore video after 1965— if only he could have conceived of a way to make money from his tapes. For evidence of Warhol's commitment to making money—-and to getting his own television show, see *The Andy Warhol Diaries,* ed. Pat Hackett, (New York: Warner Books, 1989).

14. Mona da Vinci, "Video: The Art of Observable Dreams," in *New Artists Video: A Critical Anthology,* ed. Gregory Battcock (New York: E. P. Dutton, 1978), 18.

15. The tendency to enlarge and project video onto a wall or screen, dominant in gallery and museum exhibition contexts since the 1980s, could be perceived as aligning video more closely to film except that most video shown in galleries is usually less than twenty minutes in length and seldom features dialogue. The diminishment of dialogue, a widespread feature in works from the 1960s and 1970s, is also a function of the diminishment of discernible content in the art video that arrives subsequently. In this sense, post-1980 art video *is* more like a "moving painting" than a "motion picture."

Eleanor Heartney

Video Installation and the Poetics of Time

by Eleanor Heartney

In an 1888 treatise entitled *Time and Free Will,* French philosopher Henri Bergson delineated two ways we experience time. One is the usual perception of linear time, in which moments are laid out one after another like beads on a chain, leading from a remembered past to an anticipated future. Bergson sees this as a flawed perception, because it treats time as another species of space.

He contrasts this perception with "duration," a more nebulous and mysterious notion. Duration, or lived time, is the experience in which time and space, past and future, are fused with the continual present. He likens duration to the perception of dance, where prior and future movements are implied at every moment in the sweep of the performer's continuous gesture. Thus, instead of making the present disappear, as happens when the linear experience of time rushes us along a prescribed path from past to future, duration creates a consciousness of our unity with the dynamic nature of the world.[1]

Early pioneers of abstraction invoked Bergson's notion of duration to explain the nature of the imagination and the crucial role played by intuition in art. They also drew on duration to suggest what was really occurring when Cubists broke up an image into multiple perspectives, thereby presenting, at one moment, a set of views that would normally be viewed successively over a period of time.[2]

Bergson's ideas were nurtured by an intellectual climate in which old ideas about space and time were under assault by new developments in science, technology, and philosophy. The general theory of relativity, first postulated by Albert Einstein in 1905, fused time and space into a single interactive entity, while the psychoanalytical theories of Sigmund Freud, conceived around the same time, suggested that our pasts are never really past, but remain as active disruptions in our present consciousness.

Today we are separated from Bergson and his age by a vast array of scientific, technological, and philosophical developments that continue to alter greatly our sense of reality and, consequently, our experiences of time and space. Among the most significant of these developments are the invention of film and video and the emergence of electronic media—phenomena which, in different ways, continue to collapse the boundaries that once separated time and space.

One wonders what Bergson would make of the capacity of film and video to stretch out the moments of time so that we can slow it down to view the successive changes as a drop of milk splashes into a cup, or speed time up so that we can see a seed germinate and flower. Would he alter his notion of duration if he encountered MTV, with its jittery jump-cuts that make a collage of time and space? What would he think of the Internet, which draws in bits of information from every part of the known universe and every moment of known history to our command instantaneously, with only a few keystrokes?

It seems reasonable to suggest that, at the beginning of the twenty-first century, we are once again pioneering new perceptions of time and space. Time has begun to be experienced as something infinitely elastic, in which the relationship between past, present, and future becomes open to human intervention. Similarly, space is no longer a static field that we traverse over time, but has become a medium to be dismantled and reassembled at will.

It is not clear yet what the consequences of this shift in consciousness will be. We can only wonder: If technology can make past and present, or here and

there, coexist; if it can even alter our records and memories of history, will reality itself cease to have any meaning? If our memories can stretch to encompass things we never really experienced, what happens to our sense of self? If we alter our consciousness, do we also alter the world? Will the machines we have created to effect these changes become more like us, or will we become more like them?

In this brave new world, art can serve as an experimental laboratory for the testing of such new possibilities. Just as Cubism suggested how early-twentieth-century scientific developments could be absorbed into our visual experience of the world, more recent developments in art give us a visual and physical way to understand the effects of the electronic revolution. One field that has been at the forefront of these explorations is video art, which depends on space and time for its very existence.

Changing the Notion of Time & Space

Video art is the child of the latter half of the twentieth century. Its birth is generally located in the early 1960s, when Nam June Paik began to warp images on television monitors and Wolf Vostell invented "de-collage," "erasing" broadcast signals through interference in a manner directly opposite to the additive process of collage. In contrast to cinema and television—which were championed as populist media—video art was championed in its early days as a populist tool: it was relatively inexpensive to create, was not dependent on broadcast facilities or elaborate lighting systems, and was often sharply critical of the blandishments of mass media.

While early video art tended to consist of single-channel tapes presented on television monitors, the field has expanded over the last four decades to encompass elaborate installations. These may incorporate large-screen projections, walls of monitors with multiple computer-coordinated channels, theatrical environmental settings, and recently, even the latest interactive technology.

These more elaborate formats allow artists to explore a variety of experiences of time and space. Sequences of images may unfold over time, like tradi-

tional cinema, or they may be broken up and spread discontinuously over stacks or rows of monitors. Images may be fractured into abstract shards of light or color. They may be repeated, doubled, slowed down, or speeded up. Closed-circuit video may place the viewer's own instantaneous or time-delayed image on the screen. The interweaving of images across the screen may mimic the syncopation of jazz, the pounding beat of disco, the soothing murmur of ambient music.

Much early video still retained something of the classical Western division between subject and object—locating the viewer as an outsider peering, as through a window, into another world. Video installation, by contrast, places the viewer's consciousness and body in the middle of the artwork. Even if it is not directly interactive, video installation implies a far more active role for the viewer.

In part this is a function of the physical environment created by video installations, which some observers have likened to theater-in-the-round, whereby the "fourth wall" that separates audience from actors has been removed. Or, alternately, it operates like a stage in which the performer has been removed and the viewer installed in his or her place.[3]

Video installation's interactive nature is also a function of the kinds of sequences that tend to be displayed on monitors, screens, and walls. In traditional film, which attempts to conjure what might be referred to as Bergsonian duration, viewers figuratively "lose" themselves in the film and become one with the fictive time portrayed on screen. Video installation, conversely, tends to interrupt any such identification. Multiple screens and discontinuous images bring viewers back to themselves by requiring them, not the video's creator, to make decisions about where to look and how to assimilate disconnected information.

Some video installations go even further, and make the viewer a character in some ongoing drama. For instance, Sam Taylor-Wood's 1995 *Travesty of a Mockery* places the hapless viewer between two large-screen projections on adjacent walls. The footage depicts a young couple engaged in domestic warfare. The pair hurl verbal abuse and physical objects at each

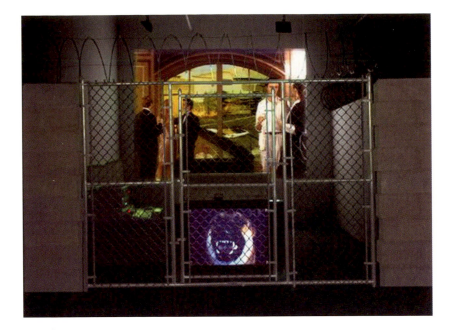

Paul Garrin
Yuppie Ghetto with Watchdog no. 9, 1989–90,
video installation. Installation view

other across the viewer's space, even occasionally crossing into the one another's screen for some particularly nasty piece of vituperation. The viewer begins to feel somehow responsible, through the act of voyeurism, or merely by his or her presence between the couple, for the battle's escalation.

The viewer is even more directly addressed in Paul Garrin's *Yuppie Ghetto with Watchdog* (1989–90), which consists of a video monitor placed directly on the floor between the viewer and a large-screen projection on the back wall. The scene in back is a cocktail party in an affluent suburban home, but the viewer is barred from entry by the video image of a snarling German Shepherd dog on the floor in front of the screen, behind an actual chain-link fence. Through the magic of interactive technology, motion sensors responding to the viewer's movements trigger the dog's actions, and he seems to follow the viewer, gaining in fury the closer the viewer approaches the fence.

Less confrontational but equally compelling is Gary Hill's *Tall Ships* (1993), in which viewers walking along a ninety-foot darkened corridor activate a series of video projections. Ghostlike figures walk forward, stand in front of the viewers, make eye contact with them, then turn and walk away. There is something particularly unsettling about the fact that the figures in the video, rather than the viewers, make the decision to break off the connection.

In such works, the physical and psychological involvement of the viewer, which is implied in all video installations, becomes explicit. In this respect, video installation is an extension and amplification of the notion of theatricality first invoked in Michael Fried's famous 1967 essay "Art and Objecthood."[4] Fried was actually writing from a Modernist position to criticize what he viewed as Minimalism's unhealthy dependence on its environment and on the location of the viewer in the surrounding space. Unlike Modernist sculpture, which was supposed to be complete in itself, he noted disapprovingly that a Minimalist object only made sense when the viewer moved around or through it.

Video art, which was born in the same decade as Minimalism, shares this "theatricality." In fact, video goes further, because it is nothing in itself, just a flash of light on the retina that leaves no trace when it is not activated. It exists only in the time and space that momentarily bring it to life. There is no physical object independent of our experience of it.

In retrospect, it is clear how much early video is a creature of its time, embracing the anti-commodity and anti-institutional ethos, the visual austerity, and the conceptual questions about the essence of the medium that permeated the avant-garde art of the 1960s and 1970s. By contrast, though video installation today retains early video's concerns with time, space, and body, it also seems to have moved toward a position that embraces the museum or gallery as its ideal environment and appears to be less concerned with machines or technology in themselves than with the often spectacular effects they can achieve.

The difference is really more one of purpose than of means. As video artist Bill Viola has noted, the technology in use today was available all along, at least in embryonic form. As he remarked, "All the threads of the medium were present when I came into it in 1970: image manipulation, intervention into the actual hardware like in Nam June Paik's work, the idea of performance and self image in that of Bruce Nauman and Vito Acconci. Taking the cinematic montage and spreading it out in space was in the work of Les Levine, and that of Frank Gillette and Ira Snyder with their early stacked monitors, which we now call video walls. These ideas developed from surveillance-system

installations of multiple monitors."[5] In fact, Viola points out, even the large-screen projections, which are often seen as the hallmark of recent video installation, first appeared in the late 1960s, in an event curated by Billy Kluver at The Armory in New York. Some artists used black-and-white video projectors designed by Bell Labs to make 30-foot-wide images on the walls.[6]

Changing the Notion of Truth

What, then, really distinguishes early video from video installation today? One answer, surprisingly, is suggested by the recent popular Hollywood film *The Blair Witch Project* and its sequel, *Blair Witch II*. *The Blair Witch Project* documents the search by a group of young film-makers for the infamous Blair Witch in a fictional forest in the Northeastern United States. The film purports to be spliced together from actual video footage that the characters shot while wandering about in the woods before their mysterious disappearance. The film's grainy black-and-white texture and jerky hand-held movements are meant to attest to its authenticity.

By contrast, *Blair Witch II,* following on the heels of its predecessor, an unexpectedly popular low-budget film, is a big-budget, full-color movie produced with all the usual Hollywood special effects. In this film, a motley group of thrill-seekers decides to re-enter the dreaded woods in search of the phenomenon that caused the disappearance of the original crew. Before long, all kinds of mysterious things happen: they find that another group of campers, whom they had encountered earlier, are now dead as the result of an apparent ritual murder; they awaken one morning in a drunken stupor, only to discover that their own video of themselves has been stolen and buried near the murder site; vehicles and drawbridges strangely disappear and reappear; and their own members begin to die in mysterious and grisly ways. Like the first crew in *The Blair Witch Project,* the second team continue to video-tape themselves during their ordeal. In the end, the "truth" is revealed when the videotapes are reviewed and turn out to be starkly at odds with the events we have just been watching on film.

In fact, the theme of the second film is stated at the outset by one of the characters, who remarks, "Film lies, video tells the truth." In one sense that statement also reflects the philosophy of early art video, which tended to define itself in opposition to the perceived inauthenticity of film and television. For early video practitioners, the role of video art was to break down the rhetorical devices of the commercial media so as to expose their manipulations and mendacity. In service of this goal, as critic Michael Rush recently noted, early video artists often trained the cameras on themselves or on their audiences in ways that curiously anticipate the current craze for Reality TV. In the 1970s, Vito Acconci created videos in which he revealed intimate things about himself or lay on the floor urging viewers to "Come in close to me. . . . Wrap your legs around me. . . . I'll be honest with you. . . ." Around the same time, Bruce Nauman created *Performance Corridor* (1969) in which, as it turned out, the performers were themselves the unsuspecting viewers.[7]

The switch from early video art to more recent video installation is, in some ways, parallel to the stylistic switch from *The Blair Witch Project* to *Blair Witch II,* or to the second film's distinction between video and film. Notions of truth and critique, along with the functionalist aesthetic of early video, seem far less important to practitioners today. Today video art, and especially video installation, is more likely to borrow from MTV or Hollywood special effects, to immerse the viewer in light and sound, and to explore the construction and disruption of traditional filmic narrative.

The difference is evident in the evolution of the work of some of the field's most eminent pioneers. Nam June Paik, often referred to as "the father of video art," first gained attention for works that playfully undermined every aspect of the then-young medium of television. He used a magnet to distort television images, or he sped up the images until they were barely decipherable; he trained a closed-circuit camera on a statue of the Buddha to allow it to contemplate its own image on television; he made aquariums of empty television sets. His more recent work has moved from such gentle critique to multimedia spectacle. For the

Nam June Paik
Installation view of *The Worlds of Nam June Paik*, 2000,
Solomon R. Guggenheim Museum, New York

centerpiece of his 2000 retrospective exhibition at
New York's Guggenheim Museum, for instance, Paik
created a laser show that played over a real waterfall,
which spilled down a seven-story rotunda toward a
floor scattered with 100 video monitors.

A similar transformation marks the work of
Mary Lucier. In *Dawn Burn,* an early work from 1979,
Lucier pointed her camera directly at the sun every
morning at dawn for seven days, creating permanent
burn marks on the surface of the camera's cathode ray
tube. The literalness of this gesture and the spareness
of its presentation have given way in her recent work
to elaborate installations that incorporate video moni-
tors or screens into environmental settings and offer
meditations on complex issues such as the tension
between nature and technology or the relationships
between death and beauty or memory and history. In
her 1993 *Noah's Raven,* for instance, video monitors
present a poetic visual narrative that ties together the
traumas caused by human intervention in the Amazon
rain forests and the Alaskan wilderness with the more
benign interventions of rubber tappers and dog sledders
and images of surgical interventions on a human body.
To bring the viewer into this imaginative universe, Lucier
has produced a mesmerizing sound track of electronic
music and placed the monitors on tree stumps and fork-
lifts in a darkened gallery. Suspended above the whole
arrangement is a full-scale skeletal replica of a pteranodon,
a large, winged reptile from the dinosaur era.

Such trajectories suggest that, in a world in
which nothing seems more staged than Reality TV,
questions of unvarnished truth and purity seem less
relevant today than they did thirty years ago. If this

is true for the pioneers of the video medium, it is even
truer for younger practitioners. Signifying, perhaps, a
shift from a Modernist to a Postmodernist world view,
the generation of video installation artists represented
in this exhibition and book are more concerned with
social, psychological, and spiritual issues than with the
medium itself or the commercial forms from which it
distinguishes itself.

Changing the Notion of Viewership

Shirin Neshat's *Rapture,* Jane & Louise Wilson's *Stasi
City*, and Pipilotti Rist's *Sip My Ocean* differ from each
other in a great many ways. However, they all create a
multi-sensory environment that is intended to wrap
around the viewer and make him or her, in some way,
part of the action. These videos also share a preoc-
cupation with allowing the viewer to penetrate worlds
normally hidden from view.

In *Rapture,* as in Neshat's other recent video
installations, the viewer is placed in a privileged posi-
tion between two groups who are themselves separated
by gender and politics. One screen presents a large
group of men wearing identical Western-style uniforms
of white shirts and black pants. They move en masse
through the corridors and ramparts of an ancient
fortress by the sea, performing ritual actions. The other
screen depicts a group of women in black veils or
Muslim chadors who move over a desert landscape to
the sea. Toward the end of the narrative, the women
pull a small wooden boat across the beach. Several
women get in and push off to the open sea.

One of the remarkable things about this work
is the way Neshat has edited the two films, which are
projected onto opposite walls. Frequently, the two
groups seem to be reacting to each other, lining up to
face off at the onset of the videos and later, periodically
interrupting their activities to "watch" the activities
on the other screen. At the end, the men line the
parapet and communally wave the women off on their
perilous journey.

The separation of the two groups in this
installation mirrors the physical separation of men
and women in Islamic culture. The differences in their
spheres are striking. The men occupy a world created by

human hands, confidently assuming control of the realm of religion, politics, and culture. The women seem, quite literally, cast out, wandering in a bleak and undifferentiated landscape that shows no evidence of human intervention. Despite the interest shown by the men in the women's final departure, there is no sense of common feeling or common destiny.

The viewer of this work is literally, as well as intellectually, caught in the middle of this male/female Islamic dialogue. We are free to identify first with one then the other screen, crossing easily between these two worlds in a way that would be impossible for the protagonists themselves. For a Western viewer, there is the added excitement of entering a hidden world whose rituals and larger meanings remain largely inaccessible.

Jane & Louise Wilson's *Stasi City* offers a similar sensation of infiltrating a forbidden space. Filmed in the abandoned headquarters of the former East German secret police in Berlin, this two-screen installation also places the viewer between two sets of related images. Here, however, there is no sense of absolute separation. Instead, the viewer may choose between two different but overlapping paths through the same space. In the process the viewer becomes, in a sense, the eye of a camera that is in constant motion. We move through a labyrinth of vacant interrogation rooms; follow the motion of an empty dumbwaiter, revolving endlessly in a sad parody of abandoned bureaucratic activity; weave through rusting surveillance equipment; and pause over poignant remnants of office furniture. Occasionally there is a ghostlike glimpse of human presence—we have a partial view of one woman riding an elevator, and another levitating above an otherwise empty room. The motion is slow, almost dreamlike, shrouding this once terrifying place with an aura of melancholy and strange nostalgia.

There is, of course, an understated irony to this work, since the Stasi served as the all-pervasive surveillance arm of the East German government. Its eyes were everywhere, leading back to the nerve center located in this once deeply guarded building. Now we become eyes surveying those eyes, moving like ghosts ourselves through this ruined monument to absolute state control.

Neshat places us at the nexus of two deeply polarized spaces. The Wilsons make us eerily complicit in the spectacle of denuded power. Pipilotti Rist wants to plunge us into a private female consciousness, using music, color, and movement to bring us into a secret world. She has spoken about her desire to create a kind of immersion effect, noting "I like installations that really get you involved, that make you part of them, or that even work like a lullaby. When I do projections, I want people to go inside them so that colors, movements, pictures are reflected on their bodies."[8]

Sip My Ocean, which was taped underwater, offers a fish-eye view of a fantasy world, full of seaweed gardens, coral reefs, schools of exotic fish. A mermaid-

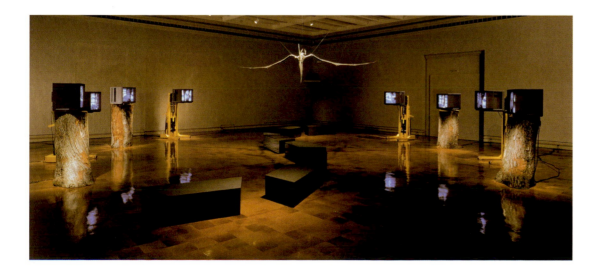

Mary Lucier
Noah's Raven, 1993, video installation
at The Toledo Museum of Art, Ohio, 1993

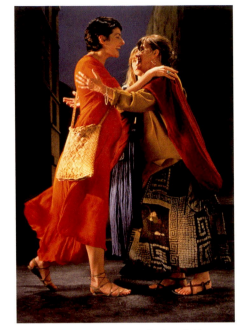

Bill Viola, *The Greeting*, 1995, single-channel video installation. Production still

Doug Aitken, *electric earth*, 1999, eight-channel video installation. Production still

like woman drifts by, household objects sink into the sea, and a soundtrack plays a love song written by Chris Isaak and performed by Rist. The kaleidoscopic images mirror each other on two screens that meet at the corner of two adjacent walls, deepening the sense of enfoldment. The angst and melancholy of the Neshat and Wilson video installations are absent here, replaced by the seductions of desire and anticipated pleasure.

Changing Notions of Reality

Each of these installations, in different ways, works to alter the viewer's sense of time and space in order to persuade us to take up residence in an alternate universe. This may explain why the museum setting, so often disdained by early video artists, has now become their location of choice. As Rist points out, "The museum often takes the place of churches and what they offered in the past. It is a space where you can try to find your presence. Not being in the past or in the future, just being there. This is what I also want with my installations. I want people to forget—for a while—yesterday and tomorrow."[9]

This sense of removal marks the work of many video installation artists today. It may be achieved by a radical re-presentation of time, undertaken to restore a lost wholeness or to capture the electronic era's sense of flux. The former approach marks Bill Viola's *The Greeting* (1995), in which the artist pays homage to an Italian Renaissance masterpiece, *The Visitation* (1516), by Jacobo Pontormo. Stretching seconds into minutes, Viola slows down the actions of three women greeting each other; in the process he transforms ordinary gestures into ritualistic actions.

A very different method of manipulating time is evident in Doug Aitken's *electric earth* (1999), which focuses on an African-American youth dancing along the deserted streets of downtown Los Angeles. Using eight simultaneous projections, circling images of storefronts, empty parking lots, and cheap motels cover the walls of a succession of rooms, encouraging viewers to join in the dance as they move from screen to screen and room to room.

Meanwhile, time is literally "out of joint" in Douglas Gordon's *Through a Looking Glass* (1999). Here, a pivotal scene from the Martin Scorsese film *Taxi Driver* (1976) is projected on two screens and manipulated in such a way that the two projections begin together, slowly fall out of sync, and merge again after half an hour.

The tendency in recent video installation to withdraw from reality is also enhanced by the use of devices that heighten our sense of physical and psychological involvement. Tony Oursler makes us the object of unexpected emotional outbursts when he projects videotaped faces onto stuffed head forms and has them call out to us in anger or anguish. Similarly Gary Hill forces us to confront an unknowable otherness when, in a work entitled *Viewer* (1996), he projects the images of a row of people standing silently along a long wall. They are neither moving nor entirely still, creating a growing tension as they seem to challenge us to break their composure.

But for all the deliberate artifice and invocation of theatricality (in both the conventional sense and in Michael Fried's more theoretical use of the word), there is another way that video installation remains grounded in a recognizable reality. As Bill Viola has pointed out, video art still depends on real light passing into a real space. In this it differs from digital art, which is composed of binary codes and exists, if anywhere, in a dematerialized zone known as cyberspace. Viola recalls with amusement meeting a student seated at a computer screen who remarked to him, "Video? Oh yeah, that's my dad's medium." Viola goes on to conclude, "Actually, technologically speaking, I don't think video is going to exist for too much longer. The technology is changing so rapidly that it simply won't be around in twenty

Tony Oursler
Blue Husk, 2001, digital video projection on fiberglass sphere with handblown glass
Virginia Museum of Fine Arts

years. Video will then be thought of as a limited practice with a finite life span, a medium that flourished briefly during the late 20th and early 21st centuries."[10]

This perhaps overly pessimistic obituary does not alter the fact that video installation today is a rich and vital medium that provides artists with valuable tools for expressing the complexity of contemporary art and life. As they grope to understand how our perceptions and even our self-conceptions have been irrevocably altered by new means of apprehending space, time, and our physical bodies, artists like those represented in this exhibition and book have much to tell us about who we are today and where we may be headed in the future. ∎

Eleanor Heartney is a contributing editor to Art in America, New Art Examiner, *and* Artpress. *A recipient of the Frank Jewitt Mather Award for distinction in art criticism, she is the author of* Critical Condition: American Culture at the Crossroads *(1997) and* Postmodernism *(2001).*

1. Henri Bergson, *Time and Free Will* (1910; reprint, New York: Harper and Row, 1960).

2. Serge Fauchereau, "Paris 1905–1915," in *Century City: Art and Culture in the Modern Metropolis* (London: Tate Gallery Publishing, 2001), 160.

3. Margaret Morse, "Video Installation Art: The Body, The Image, and the Space-in-Between," in *Illuminating Video* (New York: Aperture Books, 1990), 158–59.

4. Michael Fried, "Art and Objecthood," *Artforum International* 5, no. 10 (1967): 15–20.

5. Quoted in Kathryn Hixon, "Points in Time: An interview with Bill Viola," *New Art Examiner* 27, no. 4 (Dec 1999/Jan 2000): 40.

6. Ibid.

7. Michael Rush, "Before 'Reality TV', There was Reality Video," *New York Times,* Sunday Arts and Leisure section, January 21, 2001, 43.

8. "Laurie Anderson and Pipilotti Rist: Conversation in the Lobby of a Hotel in Berlin," *Parkett,* no. 48 (1996): 114–19.

9. Christine Ross, "Fantasy and Distraction: An Interview with Pipilotti Rist," *Afterimage* (Nov/Dec 2000): 8.

10. Quoted in Virginia Rutledge, "Art at the End of the Optical Age," *Art in America* 86, (March 1998): 70–77.

Jonathan Knight Crary

Perceptual Modulations: Reinventing the Spectator

by Jonathan Knight Crary

When did human perception become inseparable from external technologies and image-making capabilities? When did the notion of a "natural," unmediated vision cease to be a significant part of how a spectator is understood? Some would reply that vision has always been shaped and determined by social and material factors, but I believe many more would agree, at least in general, that during the twentieth century something unprecedented happened to the experience of perception within Western (and now global) urban culture. As early as the 1850s, the French poet and critic Charles Baudelaire was responding both to the invention of photography and to the plural sensory field of the emerging modern city. He identified the modern observer as a mobile, kaleidoscopic viewpoint onto a constantly modulating world animated by a cycle of obsolescence and novelty. He was also one of the first to intuit the massive reshaping of memory and time by the invention of photography.

Responding to these modernizing developments, others, such as the nineteenth-century English writer John Ruskin, lamented the disappearance of traditional modes of contemplation and deplored the centrality of habit and distraction amid mass-produced forms of visual stimulation. By the very early twentieth century, a decade after the invention of cinema, the German critic Georg Simmel not only characterized modern mental life as "the swift and continuous shift of internal and external stimuli . . . the rapid telescoping of changing images,"[1] but also suggested the increasing unlikelihood of any individual existing outside of a passive-receptive relation to the "stream" of information and sensation. But the hyperbolic nature of such accounts obscures the fact that well into the first half of the twentieth century, urban life was still a patchwork of older perceptual experiences *and* the effects of modern processes and institutions. It was this mixed texture, with its jarring contrasts, that led to relatively extreme descriptions of sensory events that, over time, and with constant use, have since become unremarkable or even unnoticed.

Perhaps the single most important turning point in the modernization of perception was the mass diffusion of television following World War II. The implantation of television as a household appliance throughout North America, and eventually over most of the planet, dissolved what had been a qualitative distinction between an exterior public sphere and a private/domestic interior space. Television crystallized elements of prior technologies such as radio, the telephone, the phonograph, and cinema. Yet it fully transcended them, in part because of the real-time tele-presence of both image and sound and because of the simultaneity of the ever-increasing flows/channels it made accessible. Television's ubiquitous physical proximity and the extended duration of perceptual interface that it elicited posed the outlines of a quasi-prosthetic relation—of an uncertain permeable borderline between individual consciousness and electronic stimuli of the cathode-ray tube. Yet it remains surprising how the arrival of television incited very little of the clamorous suspicion that had greeted previous technological innovations. This social nonchalance was perhaps in part due to an extended public awareness of television in its experimental and developmental forms for two decades before its triumphant years following World War II. Rather than providing a form of spectacle that would contrast with the rhythms of everyday life (which the cinema provided), television came to constitute everyday life itself, to be its ever-present metronome. By now,

scientific research has shown conclusively that extended television viewing induces neurological conditions with remarkable similarities to nonwaking states, such as sleep or trance. At the same time statistics indicate that, for the average North American who lives to be 70 years old, about 23 of those years will be spent sleeping and dreaming and, depending on which figures are used, between 12 and 16 years will be spent watching television. In this sense there has been an unparalleled shift in the economy of collective mental life—a shift whose long-term social consequences are not yet known. But now, research is demonstrating that sustained interface with a computer monitor, regardless of how interactive, generates related forms of psychic dissociation.

One of the difficulties in writing about television or any form of modern medium is the understandable assumption that the word "television" designates a stable phenomenon with a set of fixed characteristics (such as Marshall McLuhan's famous declaration that TV was a "cool" medium, radio a "hot" one, and dozens of other influential analyses), and my own discussion thus far is complicit with this assumption. Clearly, there are periods of relative constancy in the functioning and cultural identity of a given medium, and for television the mid-1950s to the early 1970s was such a period. Now, with hindsight, it's clear that decisive changes began in the mid-1970s: not only a tilt to globalization in a world economy but also the initial spread of the personal computer as a core product for individual consumption. The interconnection of emerging global data networks with the digitalization of consumer culture was to culminate in the popularization of the Internet in the mid-1990s. But in terms of the cultural and phenomenological status of perception, the mid- to late 1970s were equally important as the start of an inexorable replacement of analog formats by digital ones in photography, film, television, and recorded sound. The ideological underpinning of film and photography had been so extensively founded on their seemingly innate mimetic capacities—on the conviction that they each bore a privileged relation to the real—that even today, well into the digital "revolution," there has only been

a partial, ambivalent uprooting of prejudices supporting the "realistic" status of media imagery. The video image, associated with real-time immediacy and the simultaneity of remote events, introduced its own enduring and transparent models of "reality." But as history shows us, there is nothing intrinsically more "real" about analog media than digital ones. It's easy to forget that, even in the very early years of photography and cinema, their technical parameters were quickly exploited to produce emphatically nonreferential images. Two examples are the photographic assemblages of Henry Peach Robinson in the 1850s, and the stop-action manipulations in the "magical" films of Georges Meliès in the late 1890s. Of course in their dominant forms, film and photography subsisted as central, even constitutive, models of realistic representation up into the 1970s.

The consequences of digital graphic technologies have been manifold, but it is important to focus on at least two of them. First, over the last two decades, there has been a progressive depreciation of the reality "value" of manufactured images of all kinds. The obvious fact that a computer-generated picture can be indistinguishable from a photograph, however, has not delivered us into some radically new era of "pure simulation" or "hyper-reality," as Jean Baudrillard, Paul Virilio, and others have proclaimed. Rather the "depreciation" is a product of a mixed environment in which most images (whether film, video, or photography) still function as though their referentiality were intact but with a vaguely defined reduction in their truth value. The second consequence of digital image technologies has been a promiscuous migration of effects and forms between what were once conceived as distinct media. And certainly much of the work featured in this exhibition and book is a self-conscious product of this aspect of contemporary media culture.

To illustrate these suggestions more concretely, consider an important media artifact from the 1960s: the Zapruder film footage of the John F. Kennedy assassination in Dallas, Texas, on November 22, 1963. As one of the most widely seen "documentary" images of all

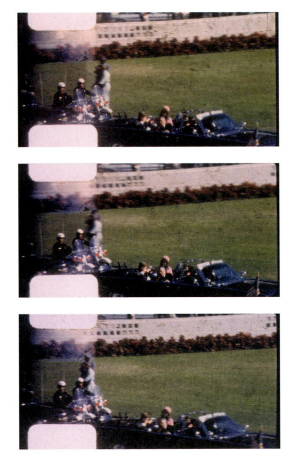

Frames 247, 248, and 249 from the Zapruder 8mm film

time, the Zapruder footage has undergone a remarkable metamorphosis in terms of its physical and cultural status. For the first twelve years of its existence, it was known to the public only through the medium of photography, through the publication of sequences of individual frames. In the mid-1970s, it was first seen as a "cinematic" event on broadcast television, and since then its visual identity has been effectively synonymous with a video image. Only an infinitesimal fraction of the billions of total viewers ever saw the Zapruder film projected as a "film." Now the only readily accessible version is a fully digitized one, available on both videocassette and DVD. Large-format transparencies of each frame of the original 8mm film footage were scanned and re-animated by computer. Scratches and dust on the film were digitally removed and a computer program was used to eliminate the shakiness resulting from the use of a hand-held camera. The DVD format now allows a range of viewing and study possibilities including zoom and slow motion. But the more such techniques have produced a sharper and enhanced image, the more opaque these pictures became on a semantic level.*

The issue I'm raising here goes well beyond the obvious widespread phenomenon of, say, the transfer of old films to newer technological formats. At stake is the affective and cognitive structure of perceptual experience. The Zapruder images, in particular of President Kennedy's head being blown apart, may seem an extreme or exceptional example, but that extremity allows its long-term fate over several decades to be more recognizable. In one sense, it is a vivid demonstration of how visual information not only exists independently of any given technological apparatus, but also, within this autonomous state, is continually mutating (in this case, leaving its origins in a primitive Bell & Howell 8mm camera far behind). The twelve-year delay before the film was seen by the public meant that it appeared in the arena of mass culture just as that

*Editor's Note: To see how the Zapruder film formed the basis of *The Eternal Frame,* a video by Ant Farm and T. R. Uthco, see page 85 in Part Three of this book.

long-standing hegemony of representational "truth" began to deteriorate, just as the assumption of a quasi-dependable relationship between photographic imagery and physical reality was collapsing. The image of Kennedy's violent death, which several decades earlier would have been a supreme incarnation of Modernist "shock," had an increasingly depleted impact in an environment where images, like information, are a raw material to be manipulated, fabricated, and distorted. Quite predictably, the more often the Zapruder film has been seen and analyzed over the last two decades, the less it produces any kind of emotive response. And the more it is studied and processed, the less any meaning can be extracted from it. As we've seen, it is an object that can be read and "interpreted" to support diametrically opposed explanations or even incompatible understandings of the laws of physics. But it is hardly a question of a pre-modern model of authenticity shifting to one of simulation and fraudulence. It could even be argued that the deeply mediated and constructed texture of new imagery is a safeguard against an uncritical acceptance of the alleged "reality" of any image. But even if this might be the case for a small minority, it appears, more importantly, that there has been a partial atrophy of the older, signifying capacities of most forms of visual data. A recent example would be the aerial photographs taken during the recent war in the Balkans that purportedly showed evidence of mass graves in what had been Serb-occupied territory and where atrocities had been reported. But rather than galvanizing public opinion, response was nullified: the press quickly reported allegations that the photographs were computer fabrications and the political and informational value of the images was effectively neutralized. We live, then, in an ocean of visual data where the significance of any individual image drifts unpredictably between a condition of irrelevant blankness and the possibility of local collective meanings.

One of the great fantasies that continues to be articulated following the so-called fall of Communism is that an ameliorative process of cultural globalization is proceeding hand-in-hand with technological innovation.

More concretely, the fantasy is that a "wired world" will allow the emergence of new forms of consensus and shared values. But it is also becoming clearer that the planetary circulation of images, information, and data of all kinds over telecommunication networks is not even remotely leading toward a unified global society but only toward a superficially homogenized consumer environment. Instead, there has been a proliferation of relatively self-sufficient micro-worlds of meaning and experience, between which intelligible exchange is less and less possible. The unfathomable amount of information available on the Internet works powerfully against the post-Enlightenment ideal of a world community of interests, based on collective standards of knowledge and verifiability. There is little question now that electronically accessible images and data can be instantly deployed in the service of anything, to prove any point of view, regardless of how pathological or fraudulent it might be, such as alien abductions or the nonexistence of the Holocaust.

It is within this context that the breakdown of any stable model of medium is particularly relevant. The belief that a given visual communications medium could be defined in terms of a set of intrinsic characteristics, deriving from Modernist cultural practices, seemed to establish a situation in which artists or audiences anywhere could connect with art works or media through a mutually understood set of fundamental terms and operations, and out of which aesthetic and social meaning could be created and communicated. For film and photography, as I have suggested, this seemed possible for various interludes during the twentieth-century, though obviously no longer. But the idea of asking (as did the formalist art critic Clement Greenberg and others) "what are the essential properties of television and video" was a quixotic project from the beginning. Any theories claiming to prescribe the timeless ontology of the video image have lapsed into irrelevance or oblivion, and the vital diversity of work featured in this exhibition and book certainly confirms the pointlessness of such theorizing. A quick look at any typical web page reveals the demolition of

the earlier media classifications and separations on which we had relied. Within the frame of a single screen view, blocks of motionless characters are interspersed with moving, rotating banners of typography and imagery; "still" photographs are immediately adjacent to insets of video clips, and audio input streams from multiple sources. What categories are applicable here? The perceptual adaptability required to negotiate this now-banal terrain becomes clearer when one considers the far denser temporal texture from which an instantaneous slice is extracted.

But individual media have not simply converged into a new visible constellation of relations. Rather it is impossible now to think of media as tools that can be isolated from larger economic and institutional transformations, specifically transformations of the imperatives and circulation time of global capitalism. What began during the 1860s to the 1890s—the decades bracketed by the writings of Baudelaire and Simmel cited earlier—was the start of a continual revolutionizing of human perception through its alignment with a range of external apparatuses and networks. At first the pace of change was slow enough that certain technological and cultural configurations had the appearance of semi-permanence (perhaps a half-generation, at most). But by the 1980s the rate at which new perceptual technologies succeeded one another in the marketplace began to accelerate dramatically.

Some claim that we are experiencing a paradigm shift in which digital network culture is replacing a typographic culture. The changes underway around us now, however, are not analogous to previous historical transformations. The rise of typographic culture did not suddenly occur after the fifteenth-century invention of the printing press and movable type. It took place

slowly over several centuries and its effects, in terms of a deeply layered spread across a social field, were not fully in place until the late eighteenth or early nineteenth centuries. Perhaps most significantly though, we are not witnessing so much a change in technological form, from one dominant arrangement of machinery systems to another, but the emergence of an unprecedented dynamic of continual innovation and obsolescence. It is not as if we are in a transitional period of adjustment to a new set of networks, as occurred with radio or the telephone, that will all seem quite mundane once everything "settles down." There is no longer the protracted time frame for any product to settle in and become securely embedded, over decades, within the activities and habits of an individual life-world. For the vast majority of people, perceptual and cognitive relationships to communication and information technology are and will continue to be estranged because of the velocity at which products appear and reconfigurations of technological systems take place. It simply precludes the possibility of ever becoming "familiar" with a given arrangement. What is significant is not the so-called content of Websites, DVDs, compact discs, video games, etc., but the sheer rapidity with which new devices and formats succeed one another. We have become habituated to the idea that switching our attention quickly and continually from one thing to another is natural and inevitable. Capitalism now depends on this intensifying perceptual adaptability and on its own capacity to speed up consumption and circulation by ceaselessly creating new social and emotional needs for images and data. Whatever is currently touted as essential to our practical needs is always already disquietingly close to the precipice of out-of-date uselessness. Life becomes an anxiety-filled sequence of replacements and

upgrades. Perception itself is so closely aligned with these rhythms that one of its main activities is continually adjusting to these shifts and permutations.

Within the current environment, the video image has been displaced from the preeminent cultural position it occupied for several decades, in relation both to individual experience and to the exercise of institutional power. It is now only one of several important flows of electronic information. The physical interface with television, video, or computer monitor has mutated and will continue to mutate into various hybrids of passivity and interactivity. Obviously, video continues to be a key component of new apparatuses and spaces, but as the artists whose work is featured in this exhibition and book demonstrate, video is increasingly capable of reinvention and dismantling and can be part of provisional and flexible strategies of creation that are external to institutional and economic imperatives. Their radical diversity shows how video can now be deployed in terms of its accumulated historical identity *and* in terms of its mobile adjacency to contemporary representational systems, even those of scientific research, archival data storage, and surveillance. The works featured here indicate the multiple pathways on which video can be activated outside of a logic of enforced technological consumption, to invest it with temporalities, sensory effects, and memory fragments that are antithetical to the dominant needs of the global image industries. ∎

Jonathan Knight Crary is a Professor in the Department of Art History at Columbia University in New York City. His books include Techniques of the Observer: On Vision and Modernity in the 19th Century *(1990) and* Suspensions of Perception: Attention, Spectacle, and Modern Culture *(2000).*

1. Georg Simmel, "The Metropolis and Mental Life," in *On Individuality and Social Forms* (Chicago, Illinois: University of Chicago Press, 1971), 325.

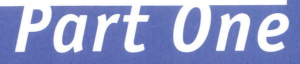

Part One

This first section in a series of three perspectives on recent video art places Pipilotti Rist's video installation *Sip My Ocean* in the context of a dozen works by other artists that were made between 1970 and 1981 for viewing on single monitors. The juxtaposition highlights Rist's use of themes, strategies, and devices from the beginning of video art's history that still, to a large degree, underlie current practice. Shared themes include sexuality, gender, and body politics; the influence of mass media on fantasy and desire; and the relationship between artist and viewer. Shared strategies and devices include body-based performance, role playing, direct audience address, elusive narratives, mirror imaging, and electronic-image processing. At the same time, *Sip My Ocean* distances itself from the gritty, experimental quality of early video art. Its environmental scale, lush color, carefully edited flow of images and, perhaps most emphatically, deliberate embrace of pleasure as both subject and end result contrast markedly with works that often adhered rigorously to concept and rejected entertainment value in an effort to distinguish themselves from television and film.

Pipilotti Rist
Sip My Ocean, 1996

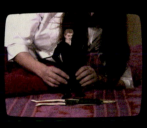

Vito Acconci
Theme Song, 1973

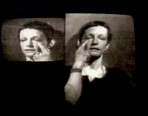

Eleanor Antin
The Adventures of a Nurse, 1976

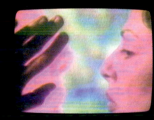

Lynda Benglis
Now, 1973

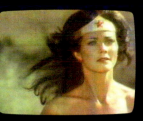

Dara Birnbaum
Technology/Transformation:
Wonder Woman, 1978–79

Fire! Hendrix, 1982

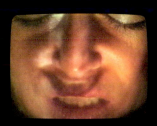

Cecelia Condit
Beneath the Skin, 1981

Joan Jonas
Left Side Right Side, 1972

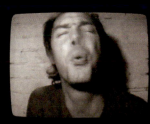

Paul McCarthy
Black and White Tapes, 1970–75

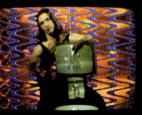

Nam June Paik
Global Groove, 1973

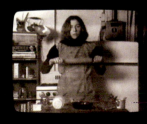

Martha Rosler
Semiotics of the Kitchen, 1975

William Wegman
Selected Works, 1970–78

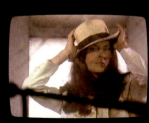

Hannah Wilke
Through the Large Glass, 1976

Pipilotti Rist

Sip My Ocean

Pipilotti Rist
Born in Rheintal, Switzerland, 1962
Lives in Zurich, Switzerland

Sip My Ocean, 1996
Two-channel video projection on walls, 8 minutes, continuous play, color, sound
Dimensions vary with installation.
Edition 1 of 3

Collection Museum of Contemporary Art, Chicago, Bernice and Kenneth Newberger Fund; restricted gift of Carol and Douglas Cohen, 1996.39

Sip My Ocean was taped almost entirely underwater. Interspersed with psychedelic abstractions, the video features the bikini-clad artist swimming in an intensely blue tropical realm. The work has a fluid eroticism, enhanced by a wide-angle lens with extreme close-ups that distort the swimmer's body and give the feeling of crawling over her skin. Rist plays on these trappings of male fantasy, familiar from music videos and advertising, but adds layers of complexity. Sinking slowly to the bottom or floating to the top, various objects, including a coffee mug, a cream pitcher, a baby doll, and a tiny plastic camping trailer, symbolize domesticity. Together with the accompanying soundtrack, in which Rist sings her own cover version of Chris Isaak's hit song *Wicked Game* (1989), with the refrain "I don't want to fall in love again," these props introduce a note of tension and irony to the visual effect of earthly paradise and overt sensuality.

Environmental in scale, *Sip My Ocean* immerses the viewer in a feeling of suspended time. It comprises two videos projected at right angles from a single source (the original format is laser disc), nearly filling a segment of the space from floor to ceiling. The projections converge in the room's corner and one image is flopped, creating a mirror image. This makes the corner function as a hinge between the projections, a stable juncture from which the imagery appears to radiate and behind which it seems to disappear, producing doubling and mutating forms that further distort and disorient. The entire piece plays in a continuous cycle with no real beginning or end, although the song repeats twice before the imagery begins a new cycle.

On one level, Rist's delirious vision conveys the pleasures and dangers of desire, treating love and heartache with doses of humor, fantasy, and angst. When viewed in the context of early works by Eleanor Antin, Lynda Benglis, Cecelia Condit, Joan Jonas, Martha Rosler, and Hannah Wilke, however, we become more aware of how *Sip My Ocean* poses fundamental questions of identity and representation that link it to feminist art of the 1960s and 1970s. Referencing music videos, Rist updates questions posed in the early works—of where an authentic self is located and whether the usual notions of female identity are primarily media fictions. As in early video art, these questions are often embedded in the issue of whose vision we experience, that is, the location and identity of the viewer and his or her relationship to the artist. (This is also a primary question for early male video artists, such as Vito Acconci. In varying ways it also underlies Shirin Neshat's *Rapture,* featured in Part Two of this exhibition and book, and Jane & Louise Wilson's *Stasi City,* the focus of Part Three.)

By placing her sexuality in the foreground, Rist might appear to act out a male fantasy uncritically, in much the same way that Hannah Wilke appears to do in *Through the Large Glass.* Cavorting in an array of colorful bikinis and subject to several lingering shots of cleavage and crotch, Rist seems intent on tantalizing the viewer. One could easily understand *Sip My Ocean* as a projected fantasy of (male) desire rather than a post-feminist statement. Toward the end of one cycle of imagery, a brief glimpse of a young man in the waves suggests that the entire scene, with the exception of these few moments, is seen through his eyes. He becomes our surrogate viewer/voyeur and underscores the notion that the imagery represents a male perspective.

On the other hand, the roving eye of the camera, pausing and swooshing, occasionally breaking the water's surface, then returning below, raises the possibility that the vision we share might be better understood as belonging to the swimmer/artist. As viewers, this would give us a privileged glimpse of her oceanic dream of womb-like return. The wide-angle lens, psychedelic colors, and abstracted images underscore the notion that we see into her mind's eye. Rist has described her rudimentary electronic image manipulations

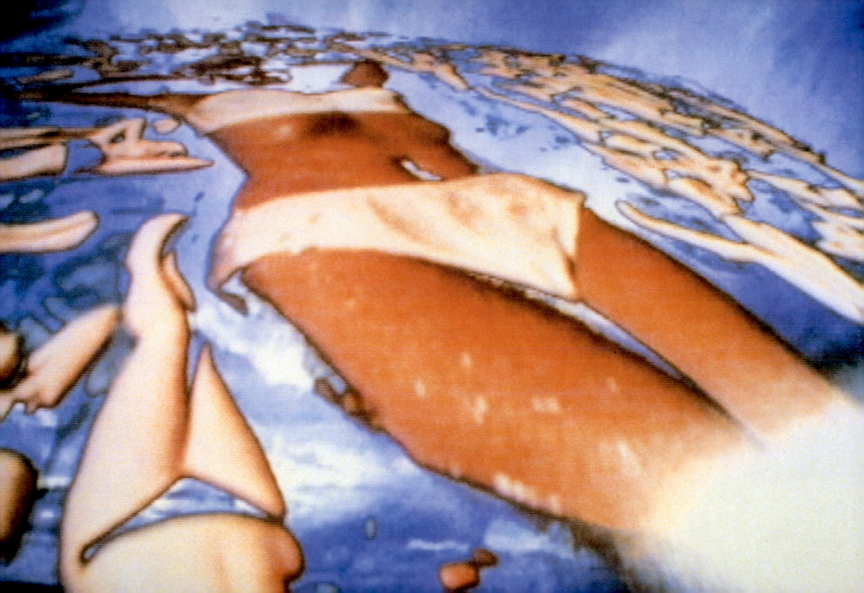

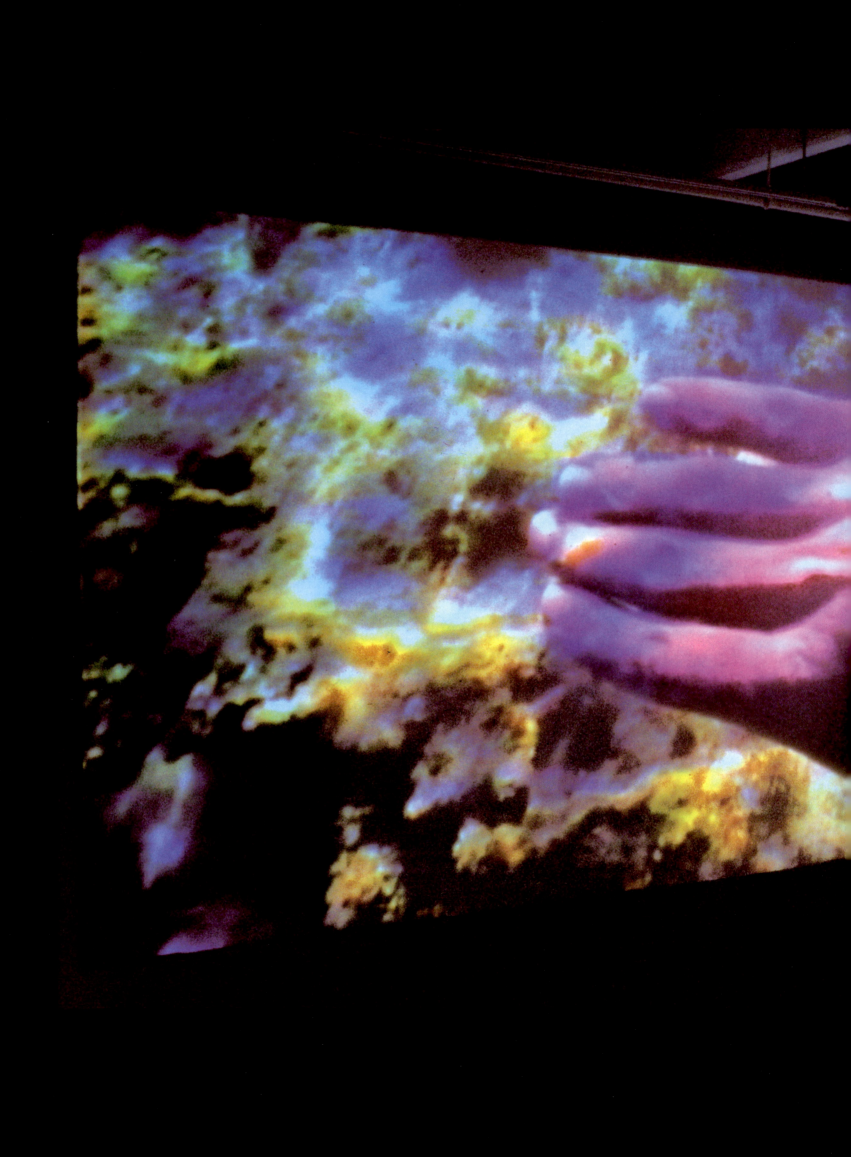

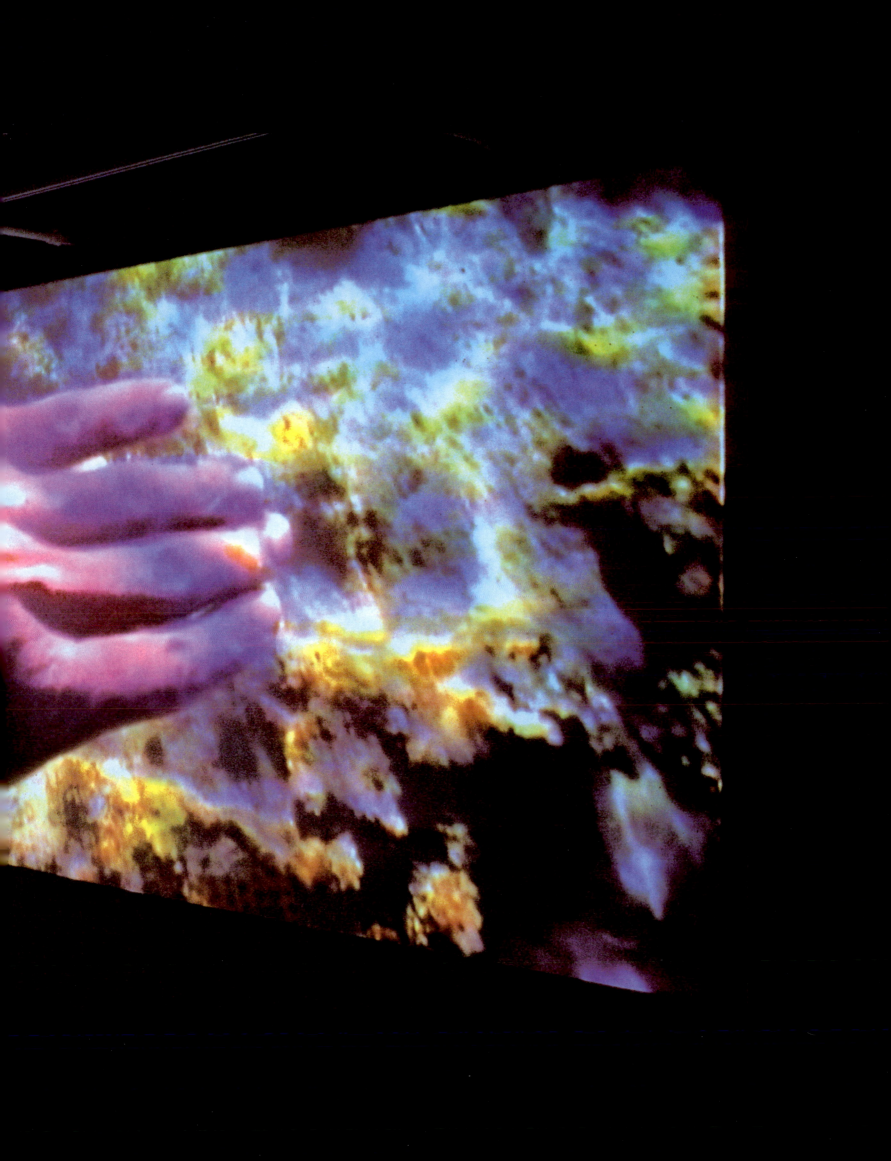

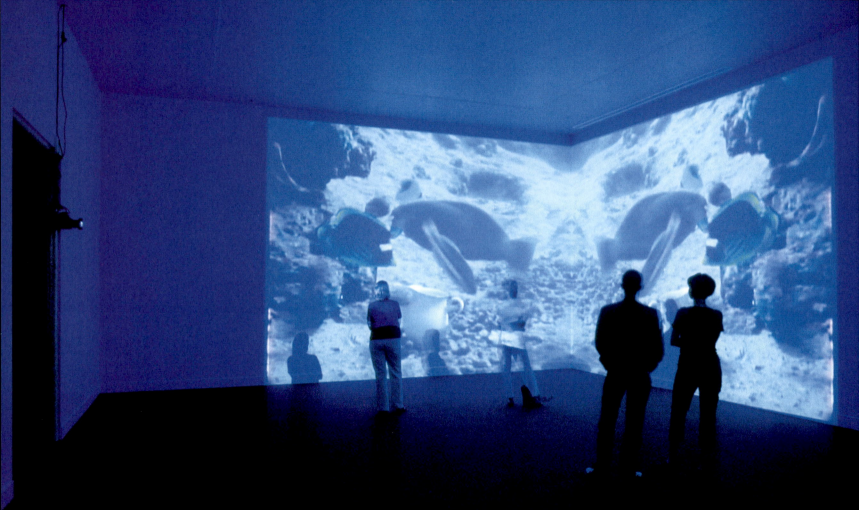

in a way that encourages this reading: "Asking too much or too little of the machines resulted in images that I was thoroughly familiar with—like my psychosomatic symptoms—that is my inner pictures."[1] She further describes her videos as "behind-glass paintings that move" whose "expressiveness or tackiness comes much closer to the truth than a perfectly sharp, slick representation."[2] Again, these comments make the images sound much like dreams.

On occasion, the camera zooms in on Rist's eyes, allowing her to return the viewer's stare. The proximity of the camera to her eyeball makes this gaze particularly physical, although it soon changes into a hallucinatory abstraction of brightly colored patterns. This direct address and physical engagement with the viewer further complicate the question of the viewer's identity and location. Like Joan Jonas in *Left Side Right Side,* Rist uses the mirror image to present a decentered and unfixed self.

The soundtrack of *Sip My Ocean* shares this quality of disjunction between various elements. In its original version, Isaak's song *Wicked Game* is a stylized and laconic expression of heartbreak. Rist plays up this emotional contrast. Her deliciously feminine vocals, accompanied by a truly elastic slide guitar, create a lulling, hypnotic effect for much of the song. The voice of rage that breaks through the sweet veneer toward the song's end comes as a shock. The laughter it sometimes produces in viewers seems less about humor than discomfort as Rist's voice approaches a wail that sounds more like a howling infant than a heartbroken

woman; her fury pierces the initial fantasy of conventional femininity. This subversion seems to support the generally irreverent quality of her vision of sex and gender, lending weight to the idea that *Sip My Ocean* celebrates female sexuality as a liberating force rather than reinforcing it as spectacle.

Rist is frequently the producer, director, camera operator, and lead actor in her work. *Sip My Ocean* exemplifies her characteristic visual aesthetic of seductive imagery, saturated colors, and low-tech special effects, frequently set to pop-based music. Rist's equal emphasis on the sound track suggests the influence of her musical background. From 1988 to 1994, she performed with her own all-female band, *Les Reines Prochaines* (The Next Queens). While studying video at the School of Design in Basel, Rist also designed stage sets for rock concerts and made music videos for local bands. Eventually, she came to work mainly in video, producing tapes, projections, and sculptural installations, which she describes as having "room in them for everything (painting, technology, language, music, movement, lousy flowing pictures, poetry, commotion, premonition of death, sex, and friendliness)—like in a compact handbag." Rist has had solo exhibitions at the Museo Nacional Centro de Arte Reina Sofia (2001), the Musée des beaux-arts de Montréal (2000), Musée d'Art Moderne de la Ville de Paris (1999), the Museum of Contemporary Art in Chicago (1996), and the Centre d'Art Contemporain in Geneva (1996), among other places. In 1997 she was awarded the Premio 2000 at the *Venice Biennale.* ∎

1. Christoph Doswald, "Ich halbiere bewusst die Welt, Pipilotti Rist im Gespräch mit Christoph Doswald," in *Be Magazin,* No. 1 (Berlin: Künstlerhaus Bethanien, 1994): 91–96.
2. *Ibid.*

Pages 34–35: Installation view at The Fabric Workshop and Museum, Philadelphia, 1999
Left: Installation view at the Musée des beaux-arts de Montréal, 2000

Single-Channel Videos

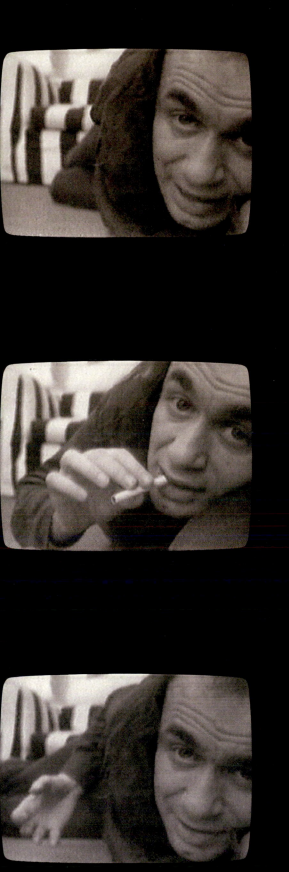

In the late 1960s, Vito Acconci began to use video and film interchangeably to document his live work, which had put him at the forefront of body-based performance art. He soon began to incorporate videos into his performances and to make independent tapes. As in his live work, the videos shifted from recording solo actions centered on his own body to exploring physical and psychological interchanges between people. Acconci's interest in behavioral psychology led him to conceive of human interaction in spatial terms, envisioned as "performance areas" and "power fields" whose boundaries and dynamics became his subjects.

In *Theme Song,* Acconci tries to influence his environment by directly addressing the viewer.[1] Lying on the floor with his face close to the camera, Acconci uses his gravelly smoker's voice in a dubious come-on. Trying sweet talk, coercion, pleading, cajoling, and a veritable barrage of clichés fueled by lines from songs by Bob Dylan, the Doors, and other popular music that he plays on his cassette player, Acconci attempts to convince us to be with him, stay with him, never leave him. As aggressive as it is, his monologue also places him in the vulnerable position of pouring out his heart to a viewer that he can't see. The desperation that surfaces in his monologue reflects in part the fact that he lacks any real control over the viewer, despite actively projecting his fantasy about who the viewer might be. *Theme Song's* treatment of relationships, love, and loss make it an important precursor for Rist's *Sip My Ocean,* as does its use of pop music to set the emotional tone; Acconci's assertive use of direct address provides an early model for Rist's own outward gaze toward the viewer. But Acconci touches on these shared concerns from a decidedly male perspective, where the desire for connection is mediated by the desire to control and manipulate. ∎

1. In her often-cited essay "Video: The Aesthetics of Narcissism," Rosalind Krauss takes another seminal Acconci work, *Centers,* as a paradigm of early video art. She notes that when Acconci looked into the video camera while making the piece, he addressed not an audience, but himself on instant playback in the monitor. (This is a working situation shared by many of the early performance-based video artists and often explored as a theme in their work, as in Jonas's *Left Side Right Side* or Benglis's *Now*). Krauss described this as a self-absorbed, hermetic enclosure of the body between the camera and the monitor, a condition that appeared to her as narcissistic self-surveillance (in *New Artists Video: A Critical Anthology,* ed. Gregory Battcock. [New York: Dutton, 1978] : 43–64.)

Vito Acconci
Born in the Bronx, New York, 1940
Lives in Brooklyn, New York

Theme Song, 1973
33 minutes 15 seconds,
black and white, sound

Distributed by Electronic Arts
Intermix, New York

Eleanor Antin
Born in the Bronx, New York, 1935
Lives in San Diego, California

The Adventures of a Nurse (Parts I and II),
1976
65 minutes, color, sound

Distributed by Electronic Arts Intermix, New York

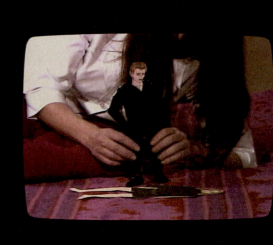

As a pioneering feminist artist in the 1960s and 1970s, Eleanor Antin originally became known for installations and photographs, often using herself as subject. In the videos she began making in 1971, and the live performances that followed soon after, she extended her use of fantasy and role playing, acting out made-up histories of a recurring cast of invented characters. In the guise of ballerina, black movie star, nurse, and king, Antin explored aspects of her own persona and social questions of how gender, ethnicity, and racial identity are constructed. These works are some of the earliest of the period to reassert the importance of biography, autobiography, and history, and to embrace narrative and humor as central devices.

In *The Adventures of a Nurse,* Antin manipulates and gives voice to paper dolls of Little Nurse Eleanor, doctors, and patients. For Antin, the nurse represented a service figure held in contempt by society. Antin was intrigued by how a noble calling had become degraded in the popular imagination, making it the subject of sexist fantasies.[1] The Little Nurse's adventures place her at the mercy of these forces, but she also demonstrates a creative and resourceful character, embellishing truth as a means of inventing her own identity. Both victim and heroine, the Little Nurse stars in her own love stories and soap operas where she ultimately transcends her victimization by men. Comprised of various episodes, the video's playlets have a casual quality and unfold at an unhurried pace. Antin's stage is her bed; we catch occasional glimpses of her dressed in a nurse's outfit, and we see her hands and arms as she moves her homemade cutout figures. The projection of fantasies onto rudimentary props recalls children's doll play, a central means by which young people rehearse gender identities. The first of two "Little Nurse" videos, *The Adventures of a Nurse* focuses on women's traditional romantic aspirations. ▮

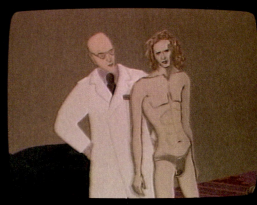

1. See Howard Fox, "A Dialogue with Eleanor Antin," pp. 213–216, and Antin as quoted in Howard Fox, "Waiting in the Wings: Desire and Destiny in the Art of Eleanor Antin," p. 88, both in *Eleanor Antin,* exhibition catalogue (Los Angeles County Museum of Art, 1999).

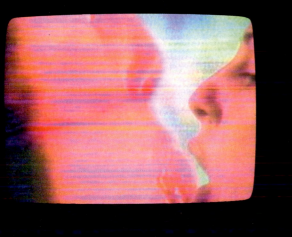

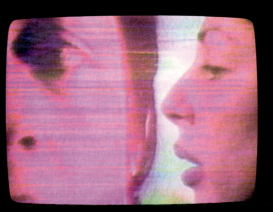

Lynda Benglis worked intensively on videos from around 1972 to 1976, during the same time that she was gaining recognition for her expressive, improvisational sculptures made with polyurethane, latex, and wax. Benglis transferred to video her sculptural interests in exploring the properties of a medium and incorporating human gesture. Featuring herself as the primary performer, she layered images in time and space and called attention to this process with her spoken texts, thereby disrupting the recorded tape's claim to representing reality. Into this formalist practice, Benglis wove a feminist agenda of role playing and identity politics, toying with conventions of gender and sexuality.

In *Now,* Benglis poses in profile against a larger profile of her face from an earlier taping. She interacts with her own image, sticking out her tongue, embracing it with her lips, and making faces and sounds in imitation. Although apparently erotically engaged, the two images never actually make contact in the same time or space, in the same "now." Eventually Benglis adds a third layer of her profiled image; a "live" image tries to copy the taped image that was formerly the live image copying the taped image—collapsing any distinction between past and present, and showing video time and space as easily manipulated conventions.

Now's disjointed and slightly frenetic quality reflects its total absorption in an experimental process. The fascination of watching Benglis technically manipulate her image is accompanied by discomfort at observing her autoerotic relationship. Varying her tone to change the meaning, Benglis repeats a limited repertoire of statements and questions: "Start recording," "Now?" and "Do you wish to direct me?" It is unclear whom she addresses, and ultimately who is in charge, as her spoken texts vary in attitude between dominance and submission, controller and controlled. As no one else is visible onscreen, the statements appear to address the viewer, but ultimately the viewer is rejected as unnecessary in Benglis's narcissistic play. This is Benglis's first color tape, and her use of high-keyed color underscores the construct's artificiality. ∎

Lynda Benglis
Born in Lake Charles, Louisiana, 1941
Lives in New York, New York; Long Island, New York; and Santa Fe, New Mexico

Now, 1973
12 minutes 30 seconds, color, sound

Distributed by Video Data Bank, Chicago

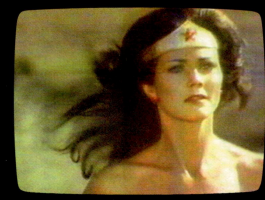

Dara Birnbaum
Born in New York, New York, 1946
Lives in New York, New York

**_Technology/
Transformation:
Wonder Woman,_** 1978–79
5 minutes 50 seconds, color,
sound

Fire! Hendrix, 1982
3 minutes 13 seconds, color,
stereo

Both tapes distributed by
Electronic Arts Intermix, New York

Dara Birnbaum began working in video in 1977 after seeing tapes by Vito Acconci and Dan Graham (whose work is also included in this exhibition and book). She is recognized as one of the early video artists to use appropriated and manipulated television imagery to critique mass media. Taking a cue from Nam June Paik, among others, she copied and reworked segments of popular television shows to reveal the underlying codes and structures of the mass media, a deconstruction intended to complicate easy consumption of its images and ideologies. Birnbaum's early works focused on representations of women, inserting a feminist perspective into her critique of corporate ideology. She has described her early tapes as attempts "to slow down the 'technological speed' of television and arrest moments of TV-time for the viewer, which would then allow for examination and questioning. . . . I wanted to explore the possibilities of a two-way system of manipulation, an attempt at 'talking back' to the media."[1]

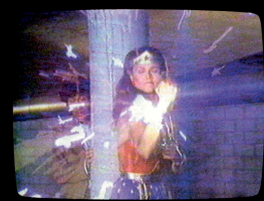

Technology/Transformation: Wonder Woman (top and center images) is one of Birnbaum's earliest and most influential works. Using segments from the popular mid-1970s television show *Wonder Woman* featuring Lynda Carter, Birnbaum diverts attention from the star's miraculous transformation from office worker to superhero and refocuses it on the artifice behind the fiction. Gestures and sequences, such as the famed spinning and explosion by which she assumes her Amazonian identity, are isolated and repeated over and over, reducing thrilling or suspenseful moments to absurd devices. As a final denouement, a scrolling transcript of every "Ooh" and "Aah" of The Wonderland Disco Band's 1979 version of the *Wonder Woman* theme song accompanies the soundtrack, laying bare the song's sexual content and gender stereotypes and draining the aura from the entire enterprise.

In *Fire! Hendrix* (bottom image), Birnbaum also uses fragmentation, repetition, and ironic juxtaposition of image and soundtrack to undermine the glamour of commercial and sexual stereotypes. Commissioned by VideoGram Inter-national, Ltd., for a videodisc of music by Jimi Hendrix, it combines scenes of cars, parking lots, drive-up fast-food windows, and a young woman drinking alone with a soundtrack of Hendrix's *Fire,* whose transcribed lyrics punctuate the images. Rapid jump cuts reflect the song's feverish rhythm, but the alienation of the urban environment contrasts markedly with Hendrix's seductive lyrics. As he sings "I have only one burning desire, let me stand next to your fire," we watch the woman drown her fire with alcohol. The use of music video's stylized editing and the tension between image and music establish a striking precedent for Rist's *Sip My Ocean.* ∎

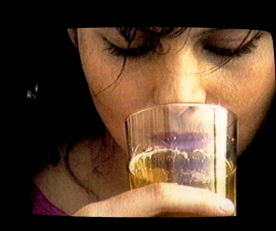

1. Dara Birnbaum, "Author's Introduction," in *Dara Birbaum, Rough Edits: Popular Image Video Works, 1977–1980* (Halifax: The Press of the Nova Scotia College of Art and Design, 1987), 13.

Cecelia Condit is known for her experimental first-person video narratives about the dark underside of female experience. Combining song, found footage, Super-8 film, and electronically processed video, she blends autobiography and fantasy to construct stylized tales of violence against women. Condit's use of humor in describing horrific events has a disarming quality. Her fascination with the appearance of the macabre in everyday life, and the way she places violence in the context of cultural myths, stereotypes, and mass-media imagery, recall the prevalence of kidnapping, torture, and murder in classic fairy tales.

One of Condit's earliest works, *Beneath the Skin* explores femininity and feminism as they intersect with sleep, dreams, violence, and death. In the story a woman unknowingly dates a man who has just killed his former girlfriend. Condit's incredulous voice-over narrative recounts what at first sounds like a distant news event about a body found in a closeted trunk. Images of a woman's face with closed eyes and of female bodies rolling downhill or sleeping suggest the state of dreaming, casting doubt on the story's truth. However, as the tale unfolds, increasingly gruesome details emerge, and the narrator's own life story places her in direct proximity to the crime. Not only is she the murderer's new girlfriend, but she has slept in the same room with the body on and off for four years without detecting its presence. Stylized images of decaying bodies and blood-red waves make lurid visual parallels to the narrative. Overlaid on the female faces and bodies, skulls and skeletons disrupt the images of ideal femininity as if revealing what is literally and figuratively beneath the skin. Commenting on the collision of opposites, the artists says, "I have always described *Beneath the Skin* as a video between worlds, swinging between fiction and the threat of reality, innocence and insanity, the macabre and the commonplace, beauty and the horrific."[1] ▌

1. From an undated artist's statement, sent to the author.

Cecelia Condit
Born in Philadelphia,
Pennsylvania, 1947
Lives in Milwaukee, Wisconsin

Beneath the Skin, 1981
12 minutes 5 seconds, color

Distributed by Electronic Arts
Intermix, New York

Joan Jonas

Born in New York, New York, 1936
Lives in New York, New York

Left Side Right Side,
1972

8 minutes 50 seconds,
black and white, sound

Distributed by Electronic Arts
Intermix, New York

With the purchase of a portable Sony video camera (the Portapak) in 1970, Joan Jonas began to incorporate video into her live performance work and to make stand-alone tapes. _Left Side Right Side_ is one of her early meditations on identity, gender, and perception—issues woven throughout her work. Steeped in late 1960s and early 1970s feminism and psychoanalytic theory, Jonas used mirrors in her work to refer to the theory of the mirror stage proposed by the French psychoanalytic philosopher Jacques Lacan, whereby the child gains awareness of itself as an integrated whole and therefore as a separate being.[1] _In Left Side Right Side,_ Jonas faces a monitor and a mirror placed side by side. A camera feeds her live image to the monitor. Located behind her, a second camera frames the images of her face in the monitor and in the mirror. Throughout the tape, the perspective switches between the first camera's single image and the second camera's double image (top image). Her multi-layered, mediated perspective complicates her attempts to identify the left and right sides of her face. Adding a further layer of complexity, Jonas holds another mirror to her face, jutting perpendicularly from the centerline (center image). The mirror bisects her face and also completes it by joining a "real" half to its reflection.

In another sequence (bottom image), Jonas draws on a chalkboard, tracing a labyrinth pattern around and around while humming. The tape shows the image in split screen, with the two images side by side, making reference to perception as a binocular (two-eyed) activity. As the lights begin to switch on and off, Jonas draws a line down the center of her face, and an X and an O on either cheek, presumably to help us keep track as she changes position each time the lights come back on. Her movements make further reference to the instability of vision: a reminder that seeing from two eyes means there is no stable image or fixed center from which to view external reality (as each eye offers a slightly different perspective). As with much early video art, _Left Side Right Side_ is grounded in an exploration of the medium's properties and the limits of perception. Yet its complex results endow these formal, perceptual exercises with social and psychological content as they confront and destabilize the structure of identity formation. ▌

1. See Jacques Lacan, "The Mirror Stage as Formative of the Function of the I as Revealed in Psychoanalytic Theory" (1949), in _Écrits—A Selection_ (New York: Tavistock Publications, 1977).

Known for his outlandish performances, installations, sculptures, and photographs, Paul McCarthy's work revels in bringing American cultural dysfunction to the conscious surface. McCarthy's work focuses in particular on themes of sex and violence that underlie our social conditioning by family and mass media. From the beginning of his video work in 1970, McCarthy's tapes have recorded his live performances. Later tapes are often shown in the context where they were made, amongst crudely constructed stage sets, store-bought props, misused condiments, and other makeshift materials. McCarthy's early works are more concrete and less theatrical than his later works, which become baroque in their excess. Nonetheless, they contain the nascent themes and strategies of his mature work. These include the use of his body as a central tool with actual and surrogate body fluids as props; a latent sense of violence, both masochistic and sadistic; and the violation of taboos as a way of assaulting cultural norms.

Black and White Tapes are McCarthy's earliest videos. They document a series of improvisational solo performances done in his studio over a five-year period. Reflecting the sense of experimentation that marked the early 1970s, they suggest the artist's resourcefulness in uniting body, props, and camera in expressive action. Three performances from the compilation are included in this exhibition and book. In *Ma Bell,* McCarthy layers the pages of the Los Angeles telephone directory with flour, an unidentified dark thick liquid, and wads of cotton. As he turns the pages, McCarthey grunts, moans, and laughs, totally absorbed in his infantile regression. In *Face Painting: Floor, White Line,* McCarthy transforms himself into a human paintbrush. Pouring paint from a can he holds in front of his head, he drags himself across the floor on his stomach, leaving a white line behind him and in the process parodying the rhetoric of Abstract Expressionists who claimed to be "in" the painting as they created it. In *Spitting on the Camera Lens,* which lasts less than a minute, the artist appears to spit directly at the viewer. Each hit is accompanied by a loud percussive sound, as the camera microphone was located just above the lens. McCarthy used a wide-angle lens, making his face appear especially close in its convex distortion, thus amplifying the sense of assault. While deliberately crude, this work has an elegance based in the economy of its transgression; one can hardly imagine a more concise breach of social norms. ▍

Paul McCarthy
Born in Salt Lake City, Utah, 1945
Lives in Los Angeles, California

Three performances from
Black and White Tapes,
1970–75
Black and white, sound

Ma Bell (1971),
7 minutes 6 seconds

Face Painting: Floor, White Line
(1972), 1 minute 58 seconds

Spitting on the Camera Lens
(1974), 55 seconds

Distributed by Electronic Arts
Intermix, New York

Nam June Paik
Born in Seoul, Korea, 1932
Lives in New York, New York

Global Groove, 1973
28 minutes 30 seconds, color,
sound

Distributed by Electronic Arts
Intermix, New York

Nam June Paik is widely considered the founder of video art. In his first solo exhibition in 1963, he displayed "prepared" television sets made by scrambling broadcast television signals with magnets and electronic devices.[1] In 1965, he produced the first art videotapes, made with the newly available Sony Portapak, a relatively portable black-and-white camera using half-inch reel-to-reel tape and external battery packs. Paik also pioneered the appropriation and manipulation of broadcast television images, electronically abstracting their forms with video synthesizers.[2] *Global Groove* is one of Paik's most influential tapes; it set the stage for future video art and commercial television production, including music videos and advertising. Even though he made *Global Groove* with professional equipment at the New York public broadcast station WNET/Thirteen (which broadcast the work in 1974), Paik retained his informal style of image processing; he used abrupt pacing shifts and rough transitions between sequences to signal his creative involvement (Pippilotti Rist's low-tech image processing in *Sip My Ocean* owes to this approach).

Global Groove begins with the statement "This is a glimpse of the video landscape of tomorrow, when you will be able to switch to any TV station on the earth, and *TV Guide* will be as fat as the Manhattan telephone book." The next twenty-eight minutes present a frenetic, imaginary global channel-surfing, sampling music, dance, and advertising from around the world. The soundtrack features rock and pop music, including *Devil with a Blue Dress On* by Mitch Ryder and the Detroit Wheels, as well as Korean instrumental music, Indian drumming, and classical excerpts by Beethoven. A hired dance team performs in the television studio, intercut with footage of traditional Korean dancers and a stripper's feather dance. Appearances by avant-garde figures from Paik's circle—John Cage, Merce Cunningham, Allen Ginsberg, and Charlotte Moorman—punctuate the tape.

Ironically modeling its format on broadcast television, *Global Groove* exemplifies Paik's ongoing efforts to free television from its commercial bias and to make it widely available as a medium of creative expression. An interactive segment toward the tape's end offers a humorous but sincere contradiction to the conventionally passive reception of one-way television broadcasting. Paik appears on the screen, instructing viewers to close their eyes, then open them, then close them three-quarters, then open them two-thirds. Meanwhile, richly colored abstract patterns, Richard Nixon's face, and an image-processed distortion of a nude are more or less visible as one follows the instructions. ∎

1. *Exposition of Music—Electronic Television* at the Galerie Parnass in Wuppertal, Germany, 1963. Also in 1963, German artist Wolf Vostell exhibited altered television sets and broadcast signals in *Television DeCollage* at the Smolin Gallery, New York.

2. In 1969, working with electronics engineer Shuya Abe, Paik invented the Paik-Abe Video Synthesizer, one of the first electronic image processors.

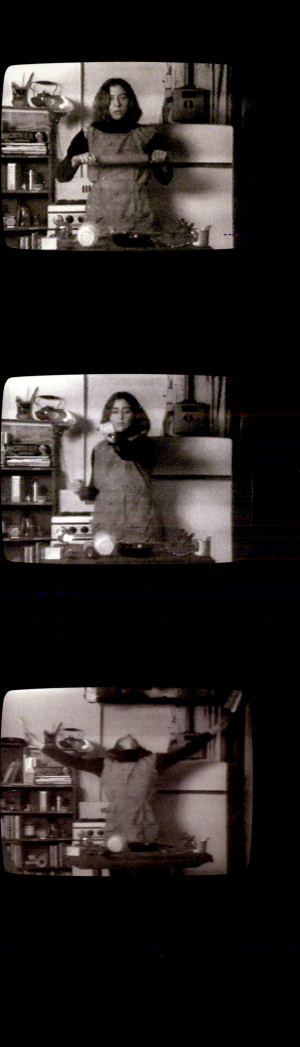

Martha Rosler's work in a range of media—performance and installation art, photography, video, art criticism, and theoretical writing—shares an overall focus on critiquing institutionalized oppression. With a perspective steeped in late-1960s and early-1970s feminism, her work exposes social injustice and cultural imperialism. Her photomontage series called *Bringing the War Home* (1967–1972) inserted news photos of the Vietnam war into stylish images taken from interior design and architecture magazines to shock viewers into awareness of the reality beyond their comfortable surroundings. The multimedia project *If You Lived Here. . .* (1989) included participation by homeless people, squatters, and community activists to address homelessness, housing shortages, and urban sprawl. Throughout her career, Rosler has explored how female identity is conditioned by society, often adopting humorous but ironic roles to act out the pressures on girls and women to conform to stereotypical gender roles.

 Semiotics of the Kitchen is one of Rosler's earliest and best-known works. Usurping the format of educational television, she acts out a cross between an alphabet lesson and a cooking demonstration. Made while she was visiting New York after having moved to San Diego, Rosler stands in the kitchen of a friend's loft and works her way from A to Z, illustrating each letter with a kitchen implement and a stylized gesture. In the mid-1970s, Rosler made a series of works in various media—such as *A Budding Gourmet* (1974), *McTowersMaid* (1975), and *Losing: A Conversation with the Parents* (1977)—exploring food, cooking, and the kitchen as key sites in the formation of female identity. Her use of kitchen props as emblems of domesticity is a precursor for the sinking objects in Rist's *Sip My Ocean,* although *Semiotics of the Kitchen* displays Rosler's feminist agenda with an uncompromising rigor. Her severe demeanor challenges the stereotype of the contented homemaker; resentment and rage bubble up to the surface in her threatening refusal to merely placate, nurture, and feed. ▎

Martha Rosler
Born in Brooklyn, New York, 1943
Lives in Brooklyn

Semiotics of the Kitchen, 1975
6 minutes 9 seconds,
black and white, sound

Distributed by Electronic Arts
Intermix, New York

William Wegman

Born in Holyoke, Massachusetts, 1943
Lives in New York, New York

Selected Works, 1970–78
19 minutes 11 seconds,
black and white and color

Milk/Floor, reel 1, 1970–72

Stomach Song, reel 1, 1970–72

Pocketbook Man, reel 1, 1970–72

Anet and Abtu, reel 1, 1970–72

Out and In, reel 1, 1970–72

Rage and Depression, reel 3, 1972–73

Massage Chair, reel 3, 1972–73

Crooked Finger, Crooked Stick, reel 3, 1972–73

Deodorant, reel 3, 1972–73

Growl, reel 4, 1973–74

Spelling Lesson, reel 4, 1973–74

Drinking Milk, reel 5, 1975

Dog Duet, reel 6, 1975–76

Starter, reel 7, 1976–77

Bad Movies, reel 7, 1976–77

House for Sale, reel 7, 1976–77

Baseball Over Horseshoes, reel 7, 1976–77

Distributed by Electronic Arts Intermix, New York

William Wegman began to make videos in 1969 while teaching at the University of Wisconsin at Madison and continued when he moved to Los Angeles and later New York. As a new medium with no real history, video allowed him the freedom to break out of the aesthetic cul-de-sac of conventional art school training. He describes wanting to deal "with things that really meant something to me, the kind of things you tend to catch yourself thinking about whether you're supposed to or not. Video was ideal for that."[1] Wegman's early interest in video lasted primarily through seven compilation reels made between 1970 and 1977.[2] These are comprised of brief vignettes enacting visual puns, sight gags, and droll monologues in a deliberately low-tech manner, using the props at hand in the home or studio. Wegman's direct address to the viewer and use of his body as both subject and primary tool reflect the impact of body-based performance art in the late 1960s and early 1970s.

While other artists of the time tried to distance their work in video from broadcast television, television's genres—particularly comedy sketches and advertising—provided Wegman with another source of inspiration. His rough imitations parodied television's conventions; the humor of his work, albeit deadpan and absurdist at times, stems from the subversion of expectations bred by popular forms and from his genuine desire to reach an audience. (Though hypothetical at the time, the notion that his works could be broadcast influenced his initial decision to work in the medium.)[3] Wegman acquired his Weimeraner dog, Man Ray, in 1970, and began to include the dog in his work. As he describes it, Man Ray "started as a space modulator, then became a kind of narrative device, then a character actor and ultimately a Roman coin."[4] Man Ray and subsequently another dog, Fay Ray, became co-actors, like straight men in a comedy team. The works in this tape, selected by the artist from his various compilation reels, include solo pieces, interactions with his dogs, and works in which only the dogs appear. ▮

1. William Wegman, "Videotapes: Seven Reels," in *William Wegman* (New York: Harry N. Abrams, 1990), 25.
2. Returning to this series Wegman made Reel 8 in 1997–98 and Reel 9 in 1999.
3. Wegman's work is now featured regularly on public television.
4. David Ross, "An Interview with William Wegman," in *William Wegman.*

A central question in Hannah Wilke's work is the representation of the female body. Working in sculpture, photography, performance, and video, she used her nude body as her primary subject. Feminist critics argued that Wilke's practice reinforced sexual stereotypes, but the rich symbolism of her work indicates a knowing questioning of cultural myths and conventions. While incorporating eroticism into her work, she self-consciously displayed the gestures of sexuality, gender, and narcissism in order to parody them.

Through the Large Glass documents Wilke's 1976 performance at the Philadelphia Museum of Art as seen through Marcel Duchamp's transparent work *The Bride Stripped Bare By Her Bachelors, Even* (1915–23; also known as *The Large Glass.*)[1] Appearing in a man's white suit and fedora hat, Wilke strikes coy modeling poses while slowly shedding articles of clothing. She maintains an aloof pout and occasionally fixes a direct stare at the viewer. Her chosen setting, *The Large Glass,* is one of the masterworks of modern art. It presents a complex treatise on the difficulty of male and female relations and, ultimately, on frustrated male desire. Denied sexual union with the "Bride," Duchamp's "Bachelors" are relegated to the role of perpetual voyeurs. Performing on video and behind glass, Wilke also combined seduction with unattainability to enact *The Large Glass's* central theme, updating it for the 1970s as an Yves Saint-Laurent and Helmut Lang fashion statement. Her androgynous outfit makes further reference to Duchamp's confusion of gender roles both in his work and his persona. *Through the Large Glass* provides a striking precursor for Rist's use of female sexuality, sharing an appeal to the appetites of the male gaze while also suggesting a self-centered auto-eroticism (also found in Lynda Benglis's work) that resists easy consumption. ▌

1. Performed June 15, 1976. This work was originally shot in 16mm film as part of the television feature film *C'est La Vie Rrose* by Hans-Christof Stenzel. Three parts were excerpted to make *Through the Large Glass,* which Wilke originally intended to show with *Philly* (1976), a black-and-white video documenting the filming of the movie and her performance.

Hannah Wilke
Born in New York, New York 1940
Died in Houston, Texas, 1993

Through the Large Glass, 1976
10 minutes 6 seconds, color, silent

Distributed by Electronic Arts Intermix, New York

Part Two

This section of the book and exhibition places Shirin Neshat's *Rapture* (1999) beside works by other artists made from 1971 to 1984. The primary issue that surfaces in this context is relationships—between men and women; between individuals and culture; and between people and space, particularly in terms of how space both reflects and conditions physical and psychological experiences. *Rapture* uses the formal device of opposition as a pervasive metaphor. This same device structures some of the early works by other artists, such as Abramović & Ulay's *Relation Work,* Acconci's *Pryings,* and Howardena Pindell's *Free, White and 21.* Acconci, as well as Abramović & Ulay, pit male and female in opposition but also in mutual dependence. Pindell looks at the effects of race and racism that set white in opposition to black. Works by Juan Downey, Mona Hatoum, and Edin Vélez explore the relationship between the artist and his or her culture, raising a question central to *Rapture*—what perspective does one adopt toward a culture when one is both insider and outsider? Works by Gary Hill, Joan Jonas, and Bill Viola give material form to space and perception, heightening awareness of the intangible element of attention, which is also a key feature in *Rapture*. That many of these works were made around 1980 indicates the shift, at the end of the 1970s, away from performance-based, body-focused work toward more complex narratives, cultural observations, and identity politics. These are all issues that, by the 1990s, had come to dominate art practice and that also underlie *Rapture*.

Shirin Neshat
Rapture, 1999

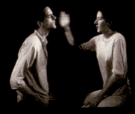

Marina Abramović & Ulay
Selections from
Relation Work, 1976–1988

Vito Acconci
Pryings, 1971

Klaus vom Bruch
The West is Alive, 1983–84

Shirley Clarke
Alan Watts—A Zen Lesson
ca. 1970

Juan Downey
Laughing Alligator, 1978

Mona Hatoum
Changing Parts, 1984

Gary Hill
Around and About, 1980

Joan Jonas
Vertical Roll, 1972

Charlemagne Palestine
Internal Tantrum, 1975

Howardena Pindell
Free, White and 21, 1980

Daniel Reeves
Smothering Dreams, 1981

Edin Vélez
Meta Mayan II, 1981

Bill Viola
*Chott-el-Djerid (A Portrait in
Light and Heat),* 1979

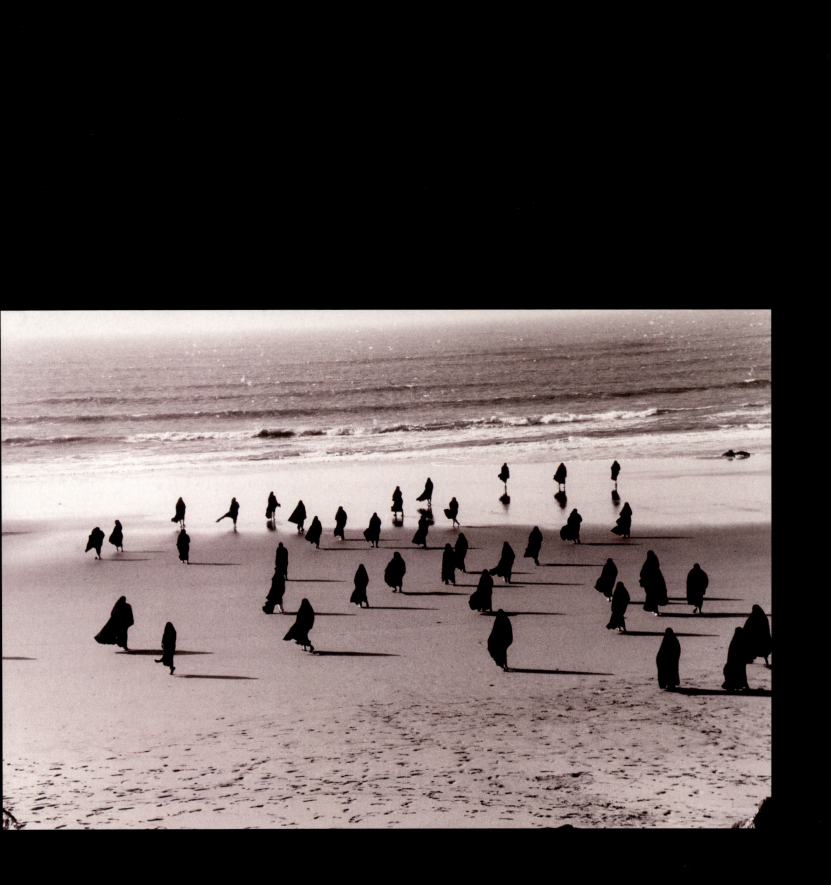

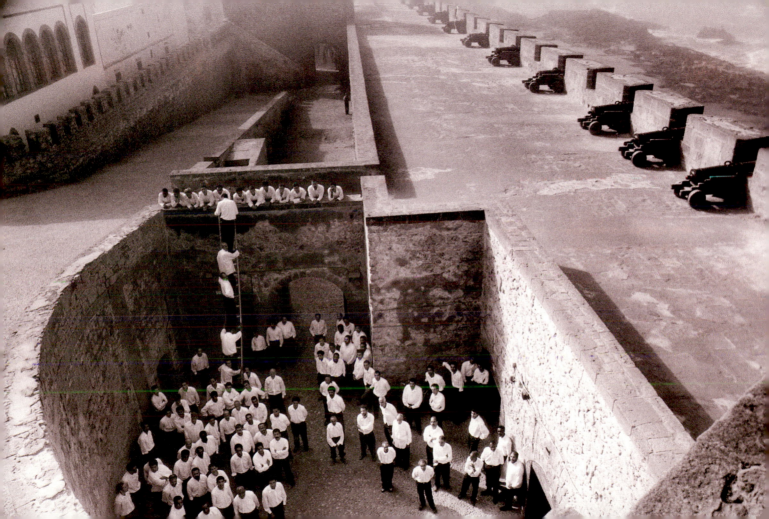

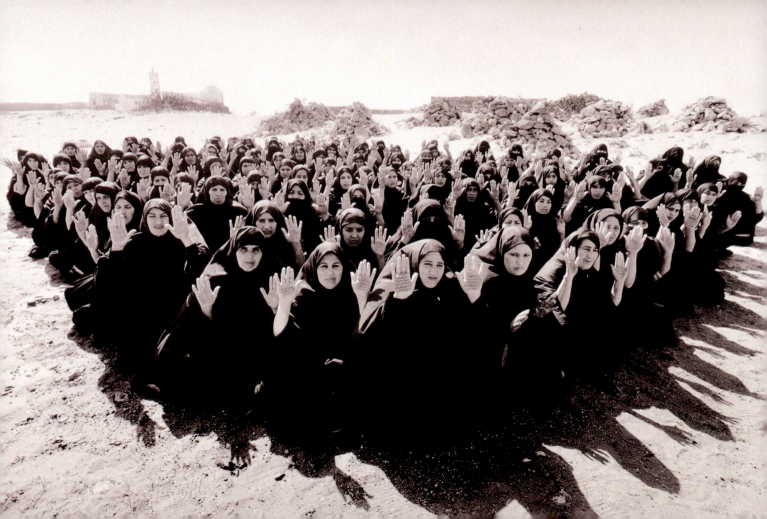

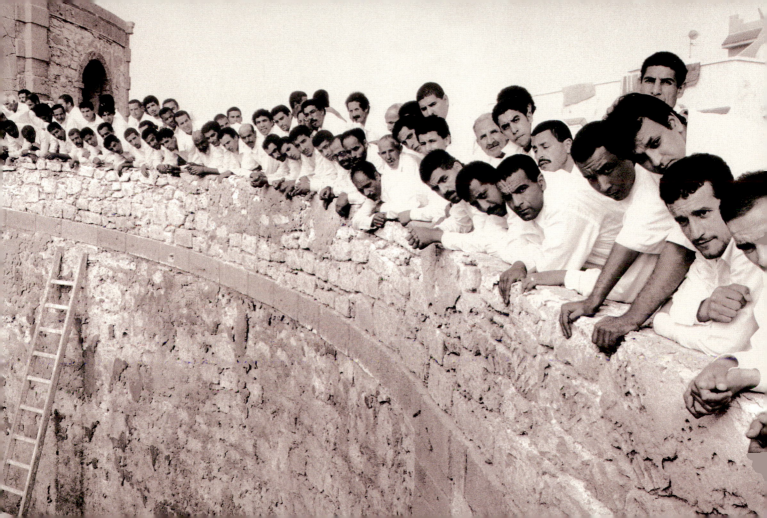

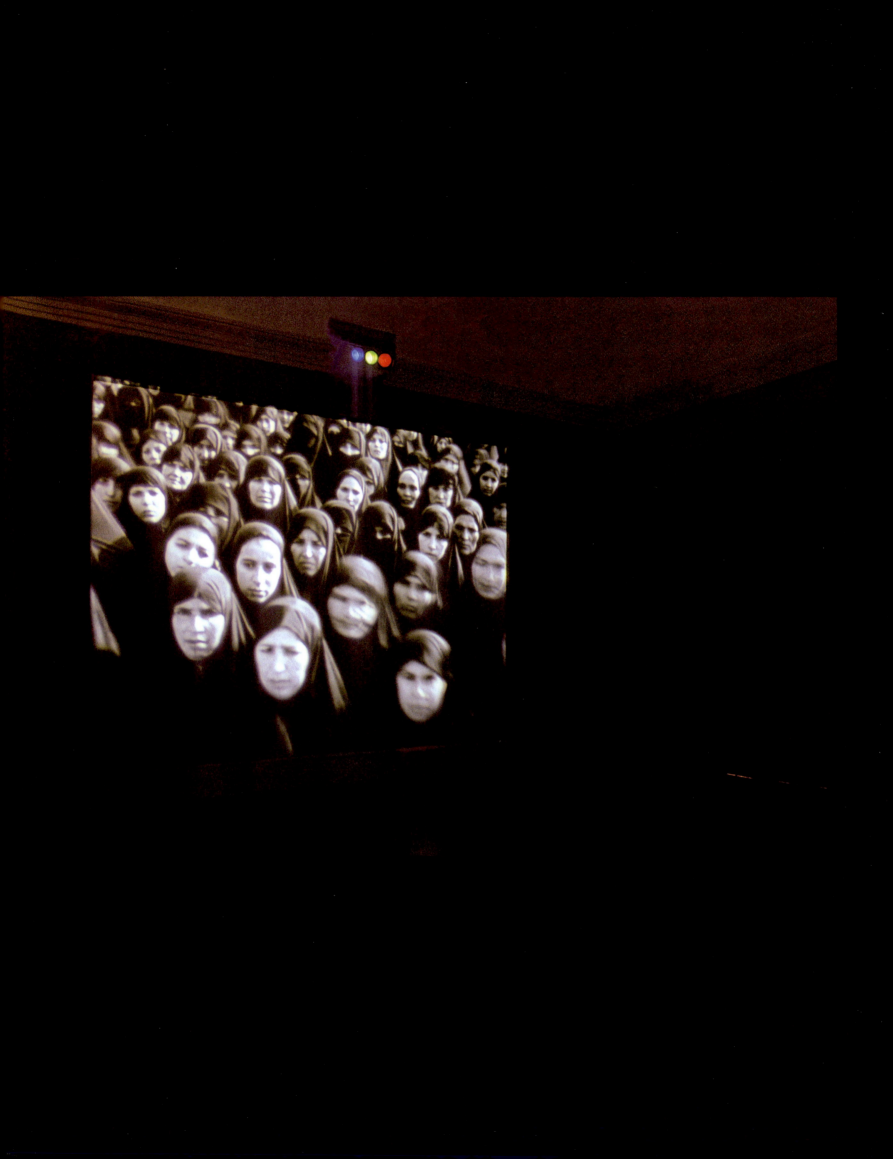

artist's own relationship with a culture to which she does and does not belong. Iran's transformation during Neshat's absence deprived her of a home. As she describes it, "Leaving has offered me incredible personal development, a sense of independence that I don't think I would have had. But there's also a great sense of isolation. And I've permanently lost a complete sense of center. I can never call any place home. I will forever be in a state of in-between. One constantly has to negotiate back and forth between one culture and the other and often they're not just different, they're in complete conflict."[7] Like works by Juan Downey and Mona Hatoum and, in a somewhat different way, by Edin Vélez, *Rapture* questions the place of the artist-observer in relation to a culture that represents "home" but to which they can no longer return. In placing

viewers at the crossroads in the opposition between the two projections, *Rapture* creates an experience that reflects the artist's own perpetual in-between, a condition that one noted scholar of exile has called a "contrapuntal state of existence."[8]

Neshat has had numerous one-person shows, including those at the Hamburger Kunsthalle, Germany (2001); the Wexner Center for the Arts, Columbus, Ohio (2000); the Art Institute of Chicago (1999); and The Tate Gallery, London (1998). *Turbulent* (1998) was shown at the *Venice Biennale* in 1999, where Neshat was awarded the Golden Lion. *Soliloquy* (1999) premiered at the *1999–2000 Carnegie International* in Pittsburgh; *Fervor* premiered at the Whitney Museum of American Art's *2000 Biennial Exhibition*. ▮

1. Lina Bertucci, "Shirin Neshat: Eastern Values," *Flash Art* 30, no. 197 (Nov/Dec 1997): 84-7.

2. Deborah Solomon, "Prudence of the Chador," *The New York Times Magazine* (March 25, 2001): 42.

3. Neshat did not originally plan to make a trilogy. She began with *Turbulent*, whose issues led to new questions about male and female relations in Islam, explored in the subsequent works. See Gerald Mott, "In Conversation with Shirin Neshat," *Shirin Neshat*, exhibition catalogue, Kunsthalle Wien and Serpentine Gallery, London, 2000, 29, and "Shirin Neshat," conversation with Arthur Danto, in *Bomb* 73 (Fall 2000): 64.

4. See Danto, *Bomb*, 65. Neshat's work has never been shown in Iran because its feminist content is considered too controversial.

5. Neshat's interest in the relationship between space and ideology, including the controlling and coding of the female body, come in part from her involvement with the Storefront for Art and Architecture, an alternative arts space at 97 Kenmare Street in New York City's lower Manhattan that she co-directed from 1984 to 1994.

6. Neshat's most recent works use single-channel projections and appear to share more with traditional film than with installation art, where activation of the entire viewing environment is a key feature. They continue to be large-scale projections for gallery or museum spaces, without fixed screening times or theater seating (although *Passage* was first shown in public at the 2001 San Francisco International Film Festival). But the viewing structure and hence the viewer's role have changed. In *Passage* (2001), we appear to be inadvertent observers to a drama that makes no specific address to the viewer (although a glimpse toward the end of a child hiding behind a rock suggests that we see from her perspective). In *Possessed* (2001), the camera at times positions us as part of the crowd, and at other times suggests an omniscient position. *Pulse* (2001) casts us as voyeurs, witnesses to an intimate scene that unfolds specifically because the solo character assumes that no one is looking.

7. Susan Horsburgh, "Middle East Daily," *Time Europe*, Wednesday, January 31, 2001 (accessed at www.time.com/time/europe/webonly/mideast/2000/08/neshat.html).

8. Edward Said, *Relections on Exile* (1984) as quoted in *Mona Hatoum* (London: Phaidon Press Limited, 1997), 113.

Pages 54–55: Production stills
Pages 56–57: Production stills
Left: Installation view at The Art Institute of Chicago, 1999

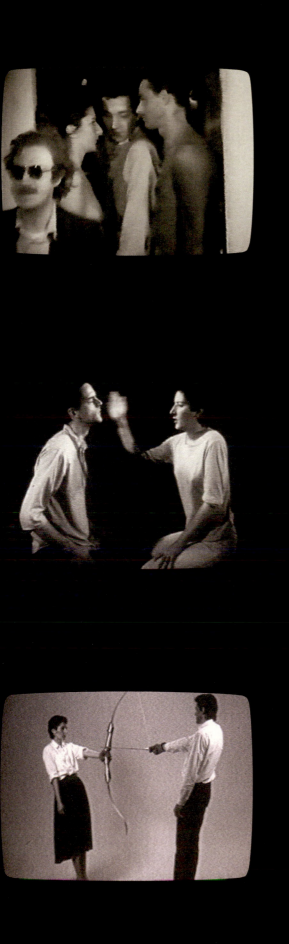

Marina Abramović and Ulay met in 1975 and began their collaborative performance-based art the following year. Abramović had begun performance work in the late 1960s, taking as a primary subject her physical and mental limits, sometimes pushed beyond consciousness. Ulay had worked in performance art, photography, video, and installation art. Together they explored male and female roles, including the notion of contrasting energies for each gender. Their collaborative work, which ended in 1988, was marked by intense commitment to process and often involved repetitive actions carried to physical and psychological extremes. Viewers of their performances became witnesses to feats of endurance and concentration based on a tense dynamic in which male and female exist in both opposition and mutual dependence.

From the start, Abramović & Ulay used video to document their work. *Imponderabilia* records a performance in Bologna, Italy (Galleria Comunale d'Arte Moderna). The couple stood naked facing each other in the main entrance, forcing the public entering the gallery to squeeze sideways between them while choosing which of the pair to face. Once inside, the audience saw themselves entering on monitors and realized that a hidden camera had filmed them. "We wanted to be a living door of the museum for three hours; after 90 minutes the police came, passing between us, and stopped the performance, asking for our passports."[1] A text on the gallery wall read, in part, "Such imponderable human factors as one's aesthetic sensitivity/ the overriding importance of imponderables in determining human conduct."

In *Light/Dark,* a twenty-minute performance in Cologne (Internationale Kunstmesse), the couple knelt facing each other, their faces lit by strong lamps. They alternately slapped each other's cheeks until one of them stopped. In *Rest Energy,* a brief performance at the international exhibition *ROSC '80* in Dublin, Ireland, they used the weight of their bodies pulling in opposite directions to hold a taut bow whose arrow pointed at Abramović's heart. Small microphones recorded their accelerating heartbeats. ∎

1. Marina Abramović, *Artist Body: Performances 1969–1998* (Milano: Edizioni Charta, 1998), 156. This book carries complete documentation of Abramović's & Ulay's performances, including transcripts of the description spoken by the artists at the beginning of each video documentation.

Marina Abramović & Ulay

Marina Abramović
Born in Belgrade, Yugoslavia, 1946
Lives in Amsterdam,
The Netherlands

Ulay
Born Uwe F. Laysiepen, in
Solingen, Germany, 1943
Lives in Amsterdam

Three performances from
Relation Work

Imponderabilia, 1977,
9 minutes 44 seconds,
black and white, sound

Light/Dark, 1977,
6 minutes 30 seconds,
black and white, sound

Rest Energy, 1980,
4 minutes 12 seconds,
color, sound

Distributed by Electronic Arts
Intermix, New York

Vito Acconci

Born in the Bronx, New York, 1940
Lives in Brooklyn, New York

Pryings, 1971
17 minutes 10 seconds,
black and white, sound

Distributed by Electronic Arts
Intermix, New York

Pryings is a prime example of Acconci's interest in the psychology of interpersonal transactions. The tape documents a live performance in which Acconci repeatedly tries to pry open real-life partner Kathy Dillon's eyes as she struggles to keep them shut. Acconci's study of behavioral psychology led him to explore extremes of human relations, often setting up situations that stress or violate conventional social boundaries. While *Pryings* revolves around a simple "exercise" (used at the time in sensitivity-training workshops), it is loaded with implications regarding vision, gender, and sexuality. Acconci wants Dillon to see, perhaps to confront something or to see him. She steadfastly refuses, clinging to blindness or to an internal vision. The intense struggle around her eyes gives the issue of sight a particularly physical basis, but also underscores the varied politics of vision.[1]

Both players appear committed to the exercise; we sense that neither will abandon nor escalate their mission. They work in silence, with fierce determination, Acconci playing the male aggressor, Dillon the female victim (whose resistance proves an equal match to his assault). Although enacting stereotypical gender roles, the performance's lack of theatrics heightens its drama. The effort appears real, even if preconceived; close-ups reveal physical and emotional stress. Their struggle sometimes gives the appearance of a passionate embrace, with Acconci cradling Dillon's head between his arms and face to get a better grasp on the task at hand. Acconci's attempt to penetrate Dillon's exterior makes an unavoidable allusion to sexual assault, although ultimately his subject is a broader study in power, trust, and vulnerability as played out between the sexes. ∎

1. In response to Rosalind Krauss's famous article, "Video: The Aesthetics of Narcissism" (in *New Artists Video: A Critical Anthology,* ed. Gregory Battcock [New York: Dutton, 1978], 43–64), and in contrast to the more common psychological interpretations of Acconci's work, Anne M. Wagner understands *Pryings* as a statement about the artist's relation to his audience. In failing to make Dillon open her eyes and see, Acconci fails to make her a witness to his actions, i.e., a viewer. Wagner relates this to a prevailing skepticism in the late 1960s and 1970s about whether a viewer even existed. "Performance, Video, and the Rhetoric of Presence," *October* 91 (Winter 2000): 59–80.

Klaus vom Bruch is one of Germany's most prominent artists working in video and multimedia installation. After studying at the California Institute of the Arts outside Los Angeles in 1975–76 with Conceptual artist John Baldessari, vom Bruch returned to Germany to study philosophy at the University of Cologne. Since the mid-1970s, he has used video to explore the clash between the individual and society, in particular focusing on issues of identity and desire in postwar Germany. Employing strategies of fragmentation, repetition, and rapid jump-cutting, vom Bruch creates explosive nonverbal montages that force collusion between the personal and the cultural. He often intersperses his own self-image among excerpts of archival war footage, appropriated clips from Hollywood movies, and television advertisements. His works enmesh subjectivity in the realms of mass media and collective memory, collapsing distinctions between past and present, personal and historical.

The West Is Alive is one of vom Bruch's most concise and forceful confrontations between individual desire and cultural mythology. It shows vom Bruch and actress Heike-Melba Fendel in a slow-motion embrace as he tries to steal a kiss. His efforts are repeatedly interrupted by found footage of a churning locomotive taken from the Hollywood movie *Showboat* (1951). Each time the camera returns to the couple, the embrace appears slightly more aggressive, while each return to the train appears to increase its relentless advance. The sound track repeats and, at a certain point, reverses a segment from a Fred Astaire film where he dances in the engine room of an ocean liner.[1] The violent, fractured spectacle ends with an ironic cliché of masculine conquest as the train plunges into a tunnel. ▌

1. Sources, date, and title translation for *The West is Alive* confirmed by vom Bruch through e-mail correspondence with the author, July 20, 2001.

Klaus vom Bruch
Born in Cologne, Germany, 1952
Lives in Cologne

*The West Is Alive
(Der Westen Lebt),*
1983–84
4 minutes 30 seconds, color, stereo sound

Distributed by Electronic Arts Intermix, New York

Shirley Clarke

Born in New York, 1920[?][1]
Died in Boston, Massachusetts,
1997

Alan Watts—A Zen Lesson, ca. 1970

5 minutes 12 seconds, black and white, sound (from *Videotapes: Series #2*)

Distributed by Electronic Arts Intermix, New York

Shirley Clarke was trained as a dancer and her films of the mid-1950s either used dance as a subject or transposed formal elements of dance into her camera work and editing. In the late 1950s and 1960s she broadened her subjects, and her films became landmarks of the American New Wave movement of independent filmmakers. Her 1963 neorealist classic *The Cool World* offered an unflinching study of the effects of poverty and racism on black youths in Harlem. In 1970, Clarke received one of the first New York State Council on the Arts grants for groups exploring the creative use of video, allowing her to buy four Sony Portapak video cameras (the award was unsolicited and was offered by the Council's director, an enthusiast of Clarke's films).[2] The following year, Clarke formed an experimental video and theater collective based at New York's Chelsea Hotel, where she lived for many years. Named after her apartment in the building's tower, the Tower Playpen (T. P.) Video Space Troupe reflected Clarke's cinema verité style. Conceived as a juxtaposition of primitive and modern impulses—"tribal but in video space"[3]—the troupe immersed itself in the new medium, incorporating it into every aspect of their lives. Clarke documented her family, friends, and social life, producing hundreds of hours of unedited tape. While the troupe disbanded in 1975, its advent marked Clarke's full-time switch to video until her final work, *Ornette: Made in America* (1985), a feature-length documentary on jazz saxophonist Ornette Coleman that combined film and video.

This piece from the T. P. Video Space Troupe tapes shows Zen philosopher Alan Watts (1915–1973) staring silently and patiently into the camera. Clarke's apartment was rigged with multiple video cameras and she often recorded visitors without their knowledge. The troupe also experimented with leaving people alone in a room with a video camera and no instructions.[4] Watts was a personal friend and one of the many visitors who came to the open apartment atmosphere to see Clarke or take part in her frequent happening-like events. It is uncertain whether Watts is aware of the camera or is waiting to begin taping—or whether this is a Zen master's idea of a video portrait. The encounter forces the ephemeral element of attention to the foreground, making it a central subject of the work and leaving the viewer to speculate about what is behind the philosopher's placid exterior. ▌

1. Conflicting dates have been published for Clarke's year of birth. Her daughter, Wendy Clarke, believes her mother was 76 or 77 when she died in 1997. Phone conversation with the author, July 7, 2001.

2. According to video artist Wendy Clarke, who was one of the founding members of the T. P. Video Space Troupe. *Ibid.*

3. *Ibid.*

4. Wendy Clarke recalls being introduced to this practice around 1970 in an experimental theater class at Sarah Lawrence College. Professor Bob Harris had left students alone in a room for five minutes with video equipment. She brought the idea back to the troupe; it also provided the basic format for her acclaimed *Love Tapes* (begun in 1977). *Ibid.*

Born and raised in Chile, and trained as an architect in Paris and New York, Juan Downey is best known for his *Video Trans America* series made in Mexico and Central and South America. The series, which he began in 1971, numbered more than 30 tapes before his death in 1993. *Laughing Alligator* chronicles Downey's encounter with the Yanomami people in the early 1970s. Based in the Northern Amazon region along the Brazil-Venezuela border, they were the largest indigenous nation in the Americas who, at that time, still retained their traditional way of life. Among their customs, the ritual consumption of the pulverized bones of their cremated dead gave rise to the perception of them as cannibals. Downey and his family lived with the Yanomamis before their extensive and devastating contact with the outside world in the 1980s. Downey described his trip as a search for his own indigenous cultural identity, a personal odyssey to recoup his South American heritage after immersion in the New York art world.[1]

Out of the encounter between the Western family and the so-called primitive tribe, Downey created an experimental documentary, mixing anthropology with autobiography and objective observations with subjective responses. Discarding the convention that the documentary camera is a neutral eye that records reality, Downey inserts himself as an active participant in the work. He uses voice-over narratives; jump-cuts to himself, his family, and urban images from New York and Brazil; and adds electronically manipulated abstract images that draw parallels between the Yanomamis' use of natural hallucinatory drugs and urban North Americans' psychedelic drug culture. In one tense moment that acknowledges how the camera's presence affects what it records, Downey's guides turn on him with bows and arrows, as if responding, either seriously or playfully, to his own "shooting" of them. For Downey, the Yanomami's "pure" unspoiled culture appeared to represent a mythic origin underlying his Latin American identity, one to which he had access, but only as a visitor. ▌

1. See Downey's statements in Deirdre Boyle, "Juan Downey's Recent Videotapes," *Afterimage* 6, nos. 1 and 2 (Summer 1978): 10.

Juan Downey
Born in Santiago, Chile, 1940
Died in New York, New York, 1993

Laughing Alligator, 1978
27 minutes 22 seconds, color, sound

Distributed by Electronic Arts Intermix, New York

Mona Hatoum

Born in Beirut, Lebanon, 1952
Lives in London, England

Changing Parts, 1984
23 minutes 3 seconds,
black and white, sound

Distributed by Vtape,
Toronto, Canada

In Mona Hatoum's work, the body serves as the primary site for exploring issues of identity, power, and conflict. During the 1990s, Hatoum became known for sculptures that used the cool geometrical forms associated with 1960s Minimalist art, but laced with elements of real or implied danger. Heated coils, taut wires, and electrified objects are some of the means by which Hatoum's work undermined the viewer's physical security as a metaphor for the vulnerability of individuals in an unstable political world. Prior to making sculpture, Hatoum worked in performance art and video. For an artist beginning her career in the early 1980s, these relatively new forms seemed more accessible. Their lack of historical baggage also allowed her freedom to incorporate her personal history as an exiled Palestinian, and to use body-centered actions to raise broader political and social issues.

One of Hatoum's earliest videos, *Changing Parts* juxtaposes images of inside and outside to suggest, as she describes it, "the big contrast between the privileged space, like the West, and the Third World, where there's death, destruction, hunger."[1] The tape begins with photographic stills that Hatoum took of her family bathroom in Beirut while visiting her parents during a lull in the war that wracked Lebanon in the late 1970s and 1980s. Focusing first on the marble-tiled floor, the leisurely paced sequence of images proceeds to survey other details of this well-worn but clean room. Throughout, Bach's *Suite No. 4* for solo cello plays. Its warm tones and orderly rhythms reinforce the intimacy and civility of the bathroom as a place of daily private ritual.

Without warning, loud static interrupts the music, followed soon after by grainy slow-motion Super 8 film footage showing the artist's hands, face, and body pressing against a transparent membrane. These images come from *Under Siege,* a seven-hour 1982 live performance in London in which the audience watched Hatoum struggle, naked, to stand inside a cramped plastic container covered on the bottom with wet clay. Accompanied by a sound collage of static, street noises, and jumbled multi-lingual news reports about war, this second sequence of images represents an invasion of the outside world into the secure interior domestic space. At the same time, it calls into question the neat dichotomy of outer and inner, public and private. Hatoum appears like a caged animal inside her plastic container, variously exploring its confines and tearing at the walls as if searching for an opening. The seeming brutality of the scene personalizes the chaos, pain, and alienation of war and exile, but also contains a sensuousness and vitality suggesting birth. Toward the end, images of the bathroom reappear, but out of alignment, suggesting the exile's inability to return to the safety of home. ▋

1. "Interview with Sara Diamond, 1987," in *Mona Hatoum* (London: Phaidon Press Limited, 1997), 127.

Gary Hill is one of the central figures in a second generation of video artists who came to the medium directly without first establishing a reputation in another art form. Along with Bill Viola, he introduced more advanced use of technology to the developing medium. Hill began working in video in the mid-1970s in upstate New York with community-based collectives and experimental workshops (including Woodstock Community Video and the Experimental Television Center). By the late 1970s he had arrived at the themes that characterize his mature work, taking consciousness itself as his primary subject. In single-channel tapes and complex, multi-monitor installations, he manipulates the relationship between language and image to draw attention to how we experience the world. His work raises questions about how language conditions perception, about the privileged place that images hold in our consciousness, and about the relationship of both language and image to our awareness of time.

Around and About was Hill's first piece to address the viewer directly. It is also one of the earliest in which he emphasizes the physical properties of the video medium through his now-characteristic disjunction between speech and vision. In this way he draws attention to the relationship between seeing and understanding. To the rhythms of his spoken text, the tape presents rapidly changing and tightly focused views of a crowded interior. The monologue conveys his frustrations and anxiety over a recently failed relationship; the images detail every object and surface of his office at the State University of New York in Buffalo. The images often appear in small boxes, presented in various configurations from left to right and then right to left, spiraling out from the center, or reconstructing a wall block by block. (The exhaustive searching within a confined space recalls the men's restless activity inside their fortress walls in *Rapture* and the pacing of a caged animal). With each syllable uttered, the view changes. The text thus drives the images at a relentless pace, suggesting a causal link between interior and exterior, as if urgent, paranoiac thought and emotion guided and framed the perception of external reality. As Hill says, it was "almost as if I wanted to abuse the images, push them around, manipulate them with words."[1] Addressing the viewer directly as "you," Hill casts him or her in the role of his ex-partner. His spoken text is both intimate and strangely impenetrable. Paired with the fractured and staccato vision of the external world, it gives the paradoxical impression of being inside someone's head, yet kept entirely on the surface. ▌

1. In Lucinda Furlong, "A Manner of Speaking," in *Gary Hill* (Baltimore: The Johns Hopkins University Press, 2000), 192.

Gary Hill
Born in Santa Monica, California, 1951
Lives in Seattle, Washington

Around and About, 1980
5 minutes, color, sound

Distributed by Electronic Arts Intermix, New York

Joan Jonas
Born in New York, New York, 1936
Lives in New York, New York

Vertical Roll, 1972
19 minutes 38 seconds,
black and white, sound

Distributed by Electronic Arts
Intermix, New York

Like Joan Jonas's *Left Side Right Side,* discussed in Part One, *Vertical Roll* bases its explorations of perception and identity on the formal properties of the medium. Jonas's interest in early- and mid-twentieth-century experimental filmmakers led her to approach video in much the same way as they did, taking the medium's particular qualities as points of departure. Jonas found that the television monitor's vertical roll reminded her of filmstrip frames. Vertical roll is the familiar malfunction of scrolling black bars that result when the frequency sent to the monitor is out of sync with the frequency in the monitor that receives it. Jonas makes this "flaw" the work's central compositional device; the various actions she performs produce the optical illusion that she interacts with the rolling bars. At varying points she bangs a spoon against a mirror and two wooden blocks together, reinforcing the roll's rhythm and creating the perception of a causal connection. At another point she jumps up and down. When in sync with the roll, she appears to be jumping over it, like an electronic jump rope. In the final image, the rolling bands appear to push her head downward and out of the monitor.

By fracturing and fragmenting her own image, Jonas rejects television's neatly packaged illusions. In place of its typically idealized representations of women, *Vertical Roll* points to female identity as a media construct whose mechanisms Jonas exposes. In addition, the ever-disrupted images draw attention to the physical properties of video space and its continuities and discontinuities with viewer space. Presented as neither an independent fictional place nor a seamless continuum with reality, the space of *Vertical Roll* represents a complex intersection of body, technology, media, and viewer. ▌

Charlemagne Palestine began making videos in the early 1970s, encouraged by Ileana Sonnabend and Leo Castelli, New York art dealers who supported the production and distribution of videos by such artists as Bruce Nauman, Nancy Holt, Keith Sonnier, and Lawrence Weiner. Known as a Minimalist musician, Palestine's work explored "pure sound"—penetrating resonances and overtones made with traditional instruments and other means, including piano, organ, tubular bells, electronics, and the human voice. His performances often took on a physical quality as he ran around the concert space while singing sustained tones to explore the room's different resonances. In other vocal pieces, he would sing gradually louder and louder while throwing himself at the walls and floors, achieving an almost trance state. Palestine has likened his energetic, ritualistic, and sometimes violent feats of endurance to mid-twentieth-century avant-garde art, including New York School painting: "I'm the living hybrid in my own work of the physical gesturality of Jackson Pollock and the spiritual color chemistry of Mark Rothko."[1] As much performance art as music, Palestine's boundary-crossing work resisted what he saw as the commercialization of Minimalism in the hands of fellow composers such as Steve Reich (born 1936), Philip Glass (born 1937), and John Adams (born 1947).[2]

Palestine's videos date mostly from the 1970s, although he has recently returned to the medium. Presenting psychologically charged and physically demanding events, these works translate his interests in sound and live performance onto tape. Like Nauman, Joan Jonas, or Paul McCarthy (whose works are also featured in this book), Palestine made *Internal Tantrum* alone in the studio in a single, unedited take before a stationary camera. Though he began with a planned action, he allowed the event to develop spontaneously. The tape begins with Palestine—dressed in his characteristic plaid shirt, close-fitting cap, and scarf—entering and kneeling before the camera. After looking into the lens he closes his eyes and begins a steady rocking and bouncing motion accompanied by a long, droning vocalization of a single tone that gradually increases in intensity. A grimace contorts his face, suggesting the sound as an expression of grief. At a certain point, he rubs, then slaps, his face in mannered self-abuse, then finally stops and stares blankly. We seem to have witnessed a private ritual that casts us either as voyeurs or as passive accomplices to an event of physical and emotional catharsis. Palestine has written that the tape provides "a reading, like on the Richter Scale, of a certain kind of emotional internal roller-coaster or earthquake."[3] ∎

1. Brian Duguid, "Charlemagne Palestine Interview," March/April 1996, at: taz3.hypereal.org/intersection/zines/est/intervs/palestin.html

2. Duguid interview, *ibid.*

3. Quoted in Electronic Arts Intermix Online Catalogue at *www.eai.org*

Charlemagne Palestine
Born Charles Martin, in New York, New York, 1947
Lives in Brussels, Belgium

Internal Tantrum, 1975
7 minutes 35 seconds, black and white, sound

Distributed by Electronic Arts Intermix, New York

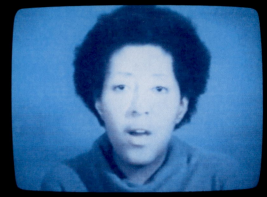

Howardena Pindell
Born in Philadelphia,
Pennsylvania, 1943
Lives in New York, New York

Free, White and 21,
1980
12 minutes 15 seconds, color,
sound

Distributed by The Kitchen,
New York

Howardena Pindell's work is often understood as having somewhat distinct phases. An early interest in figuration led, in the 1970s, to abstract works that emphasized process and materials. Pindell built up the surfaces of these often small-scaled, intimate works using confetti-like dots that she hole-punched from paper and painted canvases. She soon began to cut up her canvases and loosely stitch them back together, adding paint, collaged images, powdered pigments, sequins, and glitter. Characterized by bright color and tactile surfaces, her abstract works exemplified Pindell's belief in the decorative as an important means of personal and cultural expression. In the mid to late 1980s, Pindell's work began to incorporate more explicit references to her own identity and to broader social and political issues. Beginning in 1986, many of her works bore the word "autobiography" in their titles and included life-sized cutouts of the artist's body. Mixing personal and social histories, these large-scale multimedia works expressed her awareness of the relationship between her experience as an African-American woman and her observations about violence, oppression, and injustice, both at home and abroad.

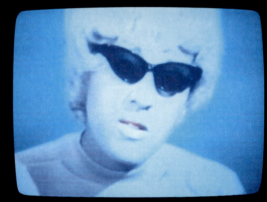

One of her few works in video, *Free, White and 21* shows that Pindell's interest in exploring the politics of race and gender actually appeared earlier in her career than is generally acknowledged.[1] As an active participant in the women's movement during the 1970s (including her role as co-founder of the prestigious New York women's cooperative gallery A.I.R.), Pindell came to feel that she was regarded as a "token" African American. *Free, White and 21* expresses her outrage at the hypocrisy of racial discrimination existing within a struggle for human liberation. The tape begins with her alone onscreen, addressing the audience. In a matter-of-fact narration, she describes her own shocking experiences of racial discrimination from childhood to the present. Interrupting her account, Pindell appears again, wrapping her head, mummy-like, with gauze bandage, as if making a futile attempt to fit into the dominant white culture. Further scene cuts interrupt her story as she appears in white face, blond wig, and dark glasses—the embodiment of her privileged counterparts—and discounts the black woman's experiences with a barrage of insulting comments: "You really are paranoid; those things never happened to you," and "You ungrateful little. . . . After all we've done for you." Like the men and women facing off across a gulf in Neshat's *Rapture, Free, White and 21* pits white and black in opposition, separated by the seemingly unbridgeable gap between their life experiences. ▌

1. Pindell has described *Free, White and 21* as the official beginning of her *Autobiography* series. See Lowery S. Sims. *The Heart of the Question: The Writings and Paintings of Howardena Pindell* (New York: Midmarch Press, 1997), 67.

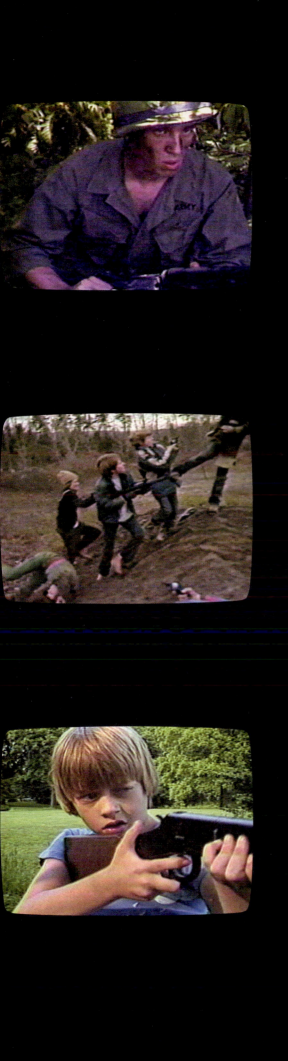

Daniel Reeves began making videos in the late 1970s at the Educational Television Center at Cornell University, Ithaca, New York. Beginning with his earliest works, he pursued an experimental documentary approach to explore themes of socially condoned violence in contemporary society. Later works focus on themes of spirituality and philosophy, including *A Mosaic for the Kali Yuga* (1986), inspired by Hindu texts, and *Sombra a Sombra* (1988), set to texts by the Peruvian poet Cesar Vallejo. Reeves rejected linear narrative in favor of layering disparate images and texts drawn from a range of sources, including staged scenes, found footage, electronically altered images, voice-over narrative, popular music, and poetry. Merging autobiography with fiction and history, his psychologically penetrating works call into question the standard distinctions between documentary, narrative, and personal expression.

Smothering Dreams is one of Reeves's earliest and most important works. It stems from his military experience as a wounded survivor of a 1968 ambush during the Tet Offensive in Vietnam, in which many in his platoon were killed. Reeves describes the work as the result of "twelve-and-a-half years of living with a memory that just would not leave me alone."[1] Part personal catharsis, part retrospective analysis, part political protest, the work intermixes actual war footage, dramatic re-enactment of the ambush, and scenes of children playing war games. The soundtrack includes voice-over narration by Reeves, excerpts of speeches against war, 1970s pop and folk music, and Wilfred Owen's "Dulce et Decorum Est," an important anti-war poem from World War I. Interspersed mass-media fragments include men on the moon and a nuclear explosion. The chaotic energy and raw rush of events interweaving dream, memory, and reality make a haunting critique of the relentless pressure on boys to learn aggression as a precursor to fighting in foreign wars. ▮

1. Marita Sturken, "What is Grace in All this Madness: the Videotapes of Dan Reeves," *Afterimage* 13, nos. 1 and 2, (Summer 1985): 24–27.

Daniel Reeves
Born in Washington, D.C., 1948
Lives in Glasgow, Scotland

Smothering Dreams,
1981
22 minutes 5 seconds, color, sound

Distributed by Electronic Arts Intermix, New York

Edin Vélez

Born in Arecibo, Puerto Rico, 1951
Lives in New York, New York

Meta Mayan II, 1981
20 minutes 2 seconds, color,
sound

Distributed by Electronic Arts
Intermix, New York

Trained as a painter in Puerto Rico, Edin Vélez discovered video when he first came to New York in 1969. He moved there permanently in 1972 and took up video as his primary medium. His early abstract colorized experiments reflect the widespread preoccupation at the time with exploring the properties of an artistic form that was still relatively new. By the late 1970s, Vélez had arrived at the experimental documentary style that characterizes his mature work, which he calls "electronic video essays." Vélez's impressionistic, subjective portraits explore diverse cultures and traditions. These include the Cuna Indians of Panama and their struggle against encroaching modernization; the world of Japanese Butoh dance; the urban melting pot of New York; and Latin American history and the myth of Columbus. Implicit in his intensely personal vision is the question of how one represents a culture, including one's own. Vélez rejects the conventional documentarian's claim to objective anthropological analysis, but he also avoids explicit political commentary. Like Juan Downey or Shirin Neshat, he takes a respectful approach to his subject that acknowledges his own perspective while also searching out tensions that underlie cultures in transition.

 Meta Mayan II is one of Vélez's early mature works. Taking as its subject the indigenous people of the Guatemalan Highlands, it follows groups of modern-day Mayan men and women as they perform daily rituals of carrying goods to market, washing clothes, shopping, and taking part in a religious procession. By isolating small gestures and expressions and slowing down all movement, Vélez further ritualizes his subjects' activities, giving weight and timelessness to everyday life. Balancing formal and ethnographic concerns, Vélez's approach heightens awareness of the beauty of the people and landscape while at the same time suggesting the tensions of a country undergoing social upheaval. All the while, a United States news broadcast describes an ongoing hostage situation in which peasant rebels have seized an embassy. In one sequence, a woman eyes the video camera with suspicion, returning its unflinching gaze with her own in a refusal to be objectified. Poetic but not romanticizing, *Meta Mayan II* raises the difficult issue of how an indigenous culture maintains its way of life while also participating on an equal footing in contemporary society. ∎

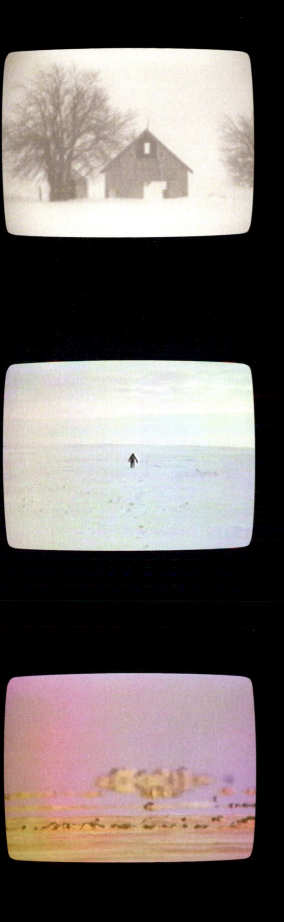

Widely considered the leading contemporary video artist, Bill Viola began working in the medium in the early 1970s at Syracuse University in New York and at the Everson Museum of Art in Syracuse, where he assisted video curator David Ross[1] and visiting artists such as Nam June Paik and Peter Campus. Viola's early tapes took the medium to new levels of sophistication and led to large-scale installations that make powerful dramas out of basic human experiences. Reflecting his interests in philosophy, religion, art history, and psychology, his works explore what Ross has called "intimations of the sublime in every-day life."[2] Viola's subjects include universal emotional states, the primary moments of human passage such as birth and death, and elemental substances such as fire and water that take on mythic proportions with his spectacular treatment.

Taking varied landscapes as its subject, *Chott el-Djerid* is one of Viola's earliest and purest statements of the parallel between outer and inner experience. The work begins in the countryside around Champagne-Urbana, Illinois. Filmed in black and white in blizzard conditions, distant farm buildings seen across snowy fields appear as faint, wavering images.[3] Their unfixed quality suggests an illusion, raising questions about the veracity of our perceptions. Presently, the image shifts to another wintry landscape, in Saskatchewan, Canada. A tiny dot on the horizon gradually advances, emerging as the artist wading through drifts. His collapse toward the foreground cues a scene shift to the arid stillness of the Chott el-Djerid, a vast Saharan salt flat in southern Tunisia. A figure tosses a rock into a small desert spring, disrupting the water's surface and leading to a sequence of mirages in which shimmering, ghostly forms populate an uncertain landscape. Describing his reasons for choosing these locations, Viola wrote, "I want to go to a place that seems like it's at the end of the world. A vantage point from which one can stand and peer out into the void—the world beyond. . . . You strain to look further, to see beyond, strain to make out familiar shapes and forms. You finally realize that the void is yourself. It is like some huge mirror for your mind."[4] In *Chott el-Djerid* the raw physicality of vision meets its limits in the illusionism of natural phenomena, and perception of space becomes an analogy for looking inward. ▪

1. At the Everson, Ross was the first video curator in the United States.

2. David Ross, "Foreword: A Feeling for the Things Themselves," in *Bill Viola,* exhibition catalogue (New York: The Whitney Museum of American Art, 1997), 24.

3. Knowing that he would complete the work by recording in the Sahara, Viola placed a butane stove under the camera lens while taping in the snowy fields, so that the rising heat waves would evoke a desert mirage (see Gene Youngblood, "Metaphysical Structuralism: The Videotapes of Bill Viola," in *Bill Viola: Survey of a Decade,* exhibition catalogue [Houston: Contemporary Arts Museum, 1988], 31.)

4. "Note, April 29, 1979," in *Bill Viola, Reasons for Knocking at an Empty House, Writings 1973–1994* (Cambridge, Massachusetts: The MIT Press, 1995), 53.

Bill Viola
Born New York, New York, 1951
Lives in Long Beach, California

*Chott el-Djerid
(A Portrait on Light
and Heat),* 1979
28 minutes, black and white and color, sound

Distributed by Electronic Arts Intermix, New York

Part Three

This third part of the book and exhibition pairs Jane & Louise Wilson's first four-channel installation piece, made in 1997, with tapes made by thirteen other artists from 1967 to 1983. The Wilsons' *Stasi City* explores the abandoned headquarters of the former East German secret police in Berlin. Both the dynamic camera work and the all-encompassing nature of the four simultaneously projected images make the viewer an active participant in uncovering the memories of suspicion, terror, and intimidation embedded in the depicted spaces. Similarly, works by James Byrne, Peter Campus, Dan Graham, Mary Lucier, and Steina emphasize perception as a central element as they probe its physical and psychological implications. Sharing *Stasi City's* focus on vision in relation to power and social control, works by Ant Farm & T. R. Uthco, Branda Miller, Marcel Odenbach, Nam June Paik, and Richard Serra appropriate media imagery and surveillance techniques to criticize the ideologies that drive them. Performance-based works by Bruce Nauman and Charlemagne Palestine, as well as Bill Viola's quasi-performative piece, also treat vision as a central theme, setting up situations that explore the relationship between observer and observed, and between external spaces and inner psychology.

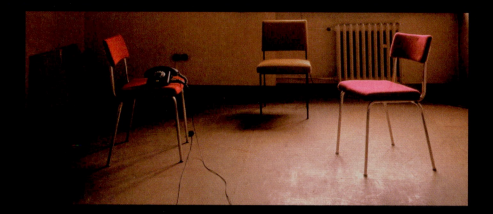

Jane & Louise Wilson
Stasi City, 1997

Ant Farm & T. R. Uthco
The Eternal Frame, 1975

James Byrne
One Way, 1979

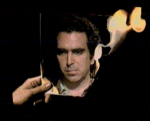

Peter Campus
Three Transitions, 1973

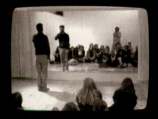

Dan Graham
Performer/Audience/Mirror, 1977

Mary Lucier
Bird's Eye, 1978

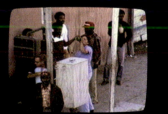

Branda Miller
L. A. Nickel, 1983

Bruce Nauman
Slow Angle Walk (Beckett Walk), 1968

Marcel Odenbach
I Do the Pain Test, 1984

Nam June Paik & Jud Yalkut
Video Tape Study No. 3, 1967–69

Charlemagne Palestine
Running Outburst, 1975

Richard Serra
Television Delivers People, 1973

Surprise Attack, 1973

Steina
Summer Salt, 1982

Bill Viola
The Space Between the Teeth, 1976

Jane & Louise Wilson
Stasi City

Jane & Louise Wilson
Born in Newcastle-upon-Tyne,
England, 1967
Live in London, England

Stasi City, 1997
Four-channel video projection
on walls, 5 minutes 40 seconds
(continuous play), color, sound
(original 16mm film transferred
to video).
Dimensions vary with installation.

Courtesy of the artists
and 303 Gallery, New York

At the beginning of *Stasi City*, in a startling moment of exposure for what was surely one of the most secret sites in modern history, the lights all switch on in the abandoned office of Erich Mielke, head of the former East German secret police. Perhaps the most feared man in that country's brief but tortured history (1949–1989), Mielke built the Ministry for State Security, popularly referred to as the Stasi, into an absurdly powerful apparatus of state control. Beginning with the division of Germany into West and East following World War II, the Stasi became the primary instrument by which the ruling Socialist Unity Party in East Germany maintained ironclad control over its citizens. Regarding everyone as a potential threat to the Communist system, the Stasi kept watch on its citizens around the clock. The Stasi maintained files on six million people, more than one third of the entire East German population. By the end, the Stasi employed 100,000 full-time agents and another 200,000 part-time informants. People spied on their colleagues, teammates, neighbors, friends, even spouses, siblings, and parents.[1] When the Communist regime collapsed within weeks of the fall of the Berlin Wall in 1989, the disintegration of the Stasi quickly followed. At the last minute, Stasi officials desperately tried to destroy incriminating files, but the sheer volume of gathered materials foiled them and most of the archives remained intact.[2]

In the Stasi, Jane & Louise Wilson found the perfect subject. Several generations removed from Marshall McLuhan's utopian concept of communications technologies creating a global village, the Wilsons train their camera on global networking as "big brother" control. Residing in Berlin in 1996 on a DAAD fellowship given to promote German studies, the Wilsons

became aware of historical architecture connected to the Cold War and the way it mapped political distinctions between East and West.[3] Through diplomacy and charm, they gained entry into the abandoned secret police headquarters, a walled complex referred to as "Stasi City" located at the end of a suburban residential street. The complex, which also contained Hohenschönhausen Prison, had been a catering depot for the Nazis and an internment camp for Stalinist Russia before becoming the center for East German intelligence. For the Wilsons, it provided the ideal location to expand their interest in what has variously been described as the pathology of the everyday, the theater of anxiety, and the architecture of repressed memory.[4]

Prior to making *Stasi City*, the Wilsons (identical twins who have worked collaboratively since graduate school) made films and videos in which they cast themselves as the primary actors. Harkening back to 1960s and 1970s performance-based video, their *Hypnotic Suggestion* (1993) and *Crawl Space* (1994) presented unedited records of their real experiences with altered states of mind—hypnosis and drug-induced hallucination, respectively. *Normapaths* and a subsequent version of *Crawl Space* (both 1995) used abandoned buildings as stage sets for more elaborate performances of fictional mini-narratives that referenced media-based memories of horror films and television action shows. Made as a split-screen video work to be shown in projections converging at right angles, *Normapaths*, in particular, integrated the concept of doubling into their work as a metaphor for the twins' own relationship. Although often sensationalized and perhaps overemphasized as an interpretive device, their twinship is consciously reflected in formal motifs of mirroring, pairing, converging, and splitting. Their practice of working collaboratively in itself places them in an important history of artistic partners whose work often takes the relationship itself as a central subject. Contemporary precedents include Abramović & Ulay and Gilbert & George.[5]

In its shift to a subject of broad historical significance and its use of two pairs of moving images projected simultaneously in opposite corners of the room, *Stasi City* marked the Wilsons' arrival at a mature

Right: *Interview Room, Hohenschönhausen Prison*, 1997, C-print mounted on aluminum. Produced in conjunction with *Stasi City*
Pages 78–79: Installation view, 303 Gallery, New York, 1997

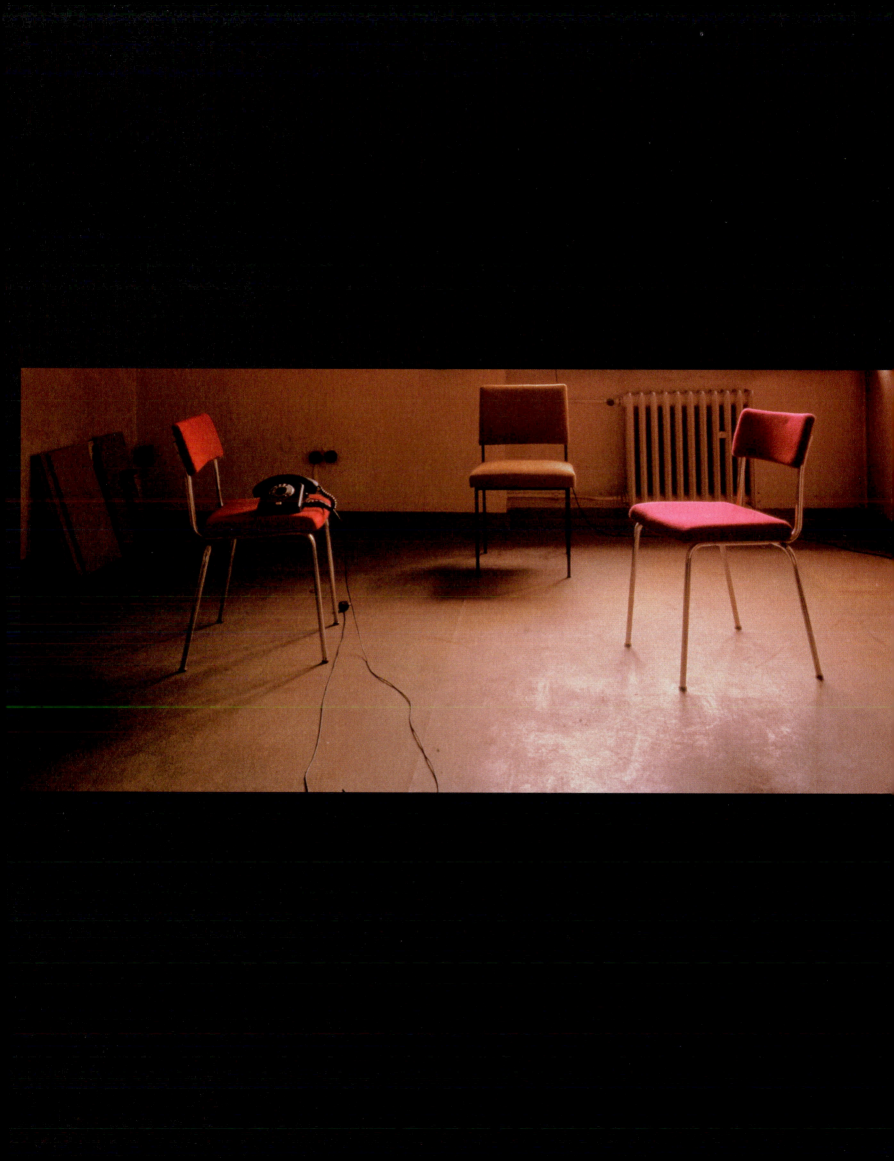

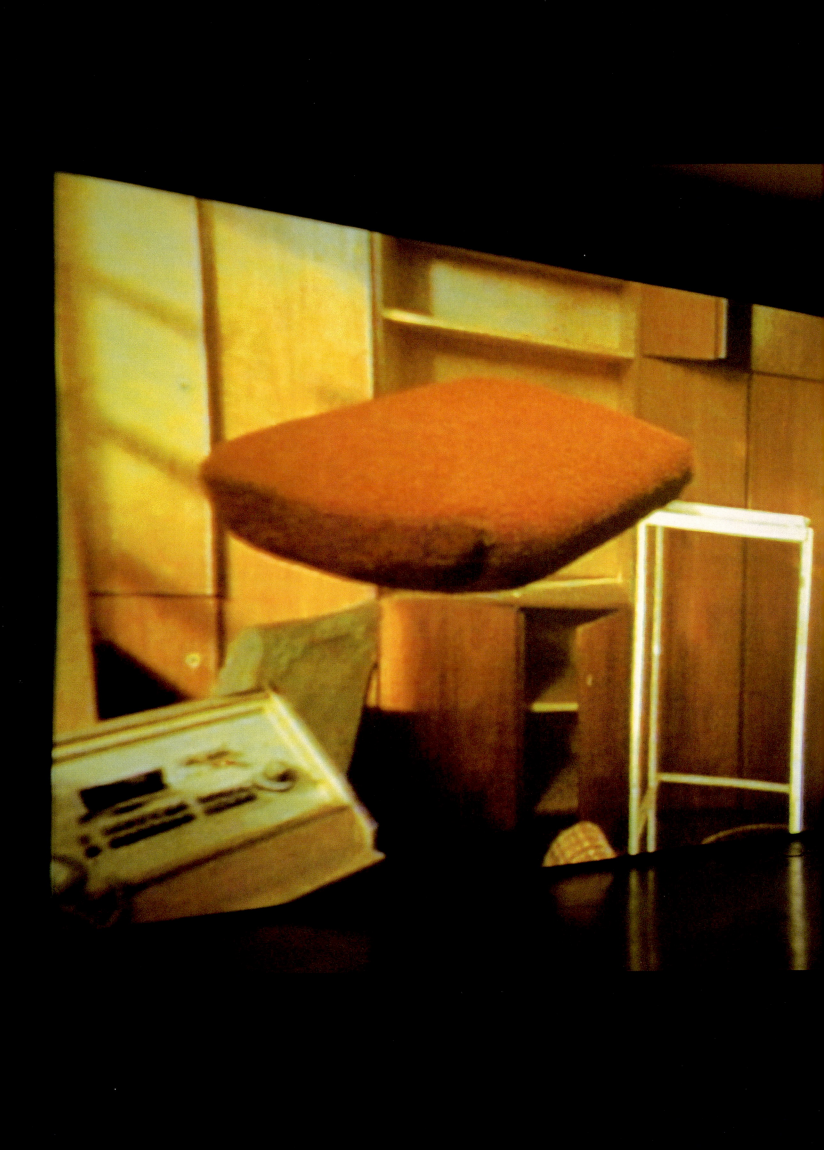

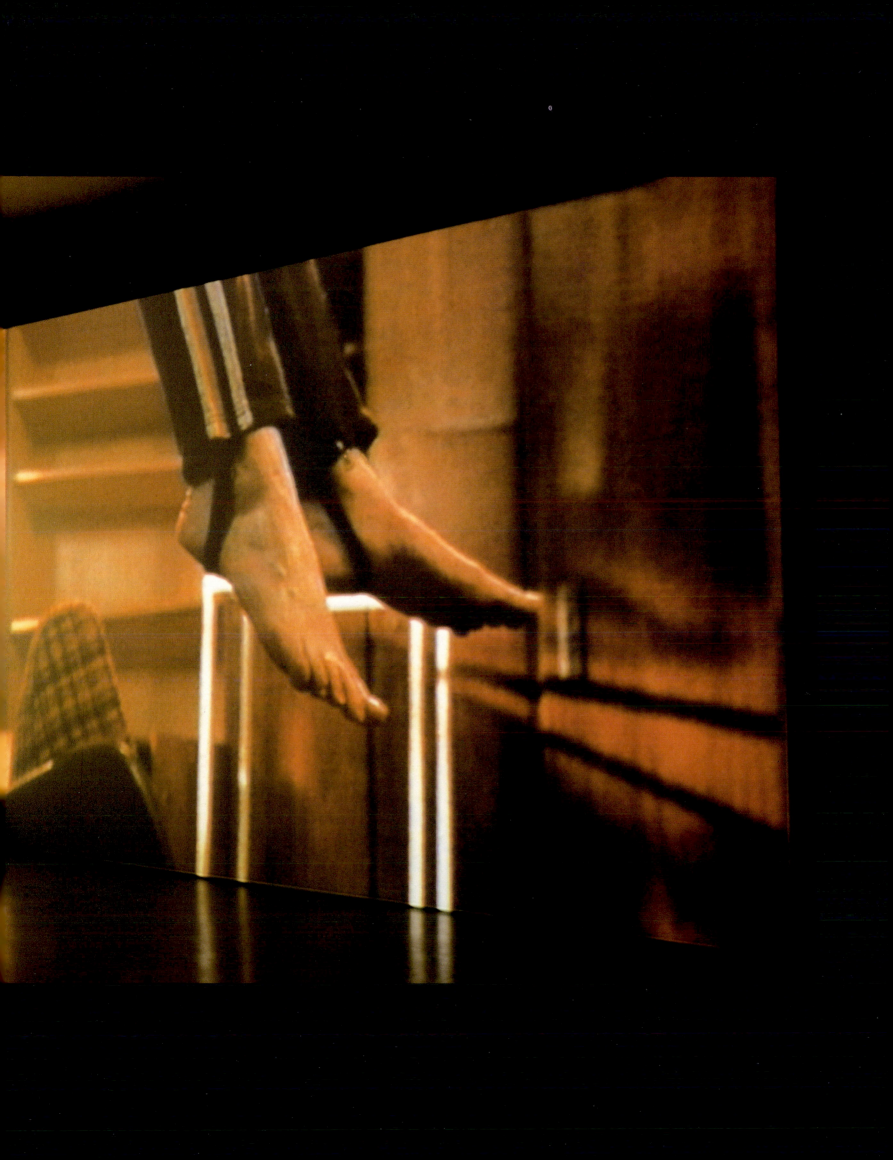

style. Although many of its themes and motifs are fore-shadowed in their previous work, *Stasi City* represents the Wilsons' first use of a site whose own actual history provides the subject. As they describe it, "The narrative comes from the location, our connection to the space that we're filming in. This makes the process entirely different from a filmmaker's script, which is driven by a pre-existent narrative. We're not imposing something. The narrative, if you can even call it that, is something that comes from within the actual place that we're examining."[6] Using a vocabulary of basic cinematic techniques—panning, zooming, tracking—the Wilsons construct a rigorously formal quasi-documentary journey through the site's interior spaces.

Given this emphasis on the space itself as subject, the Wilsons downplay their presence as actors. They do, however, make cameo appearances, as in all of their recent work. Shortly after the lights flicker on in Mielke's offices, a female figure in a blue jumper and shirt, black shoes, and clutching a shoulder bag steps off a daybed in Mielke's office, triggering the shutter release and flash of a camera. She wears the uniform of female prisoners in Hohenschönhausen Prison. The bag she carries conceals a surveillance camera. Her subtle violation of normal codes by standing on the furniture and her downward step activate the space as if starting the journey. This sequence also suggests the triggering of dreamlike memory, a merger of past and present, fact and fiction. Footsteps that subsequently echo in the stairways might belong to her. She appears briefly in the open elevators that restlessly move between floors. A secret door opening behind a wall of cabinets reveals her exiting into an adjoining chamber.

In a dramatic moment toward the end, an androgynous figure dressed in a 1970s East German track uniform lifts slowly off the floor. Hovering mid-air in one of the interrogation rooms, this figure has been read as a symbol of psychological release for victims of torture for whom mental dissociation from their body provides the only escape.[7] Referencing the Communist space exploration program as an ironic contrast to the strict confinement and regulation of citizens within East Germany, the Wilsons also note the "incongruity between challenging and conquering outer space, but

not being able to traverse one's streets. Psychologically it was a kind of zero gravity."[8] Joining the figure, a flask rises up to float in space. This moment of suspended time and heightened anxiety comes to an abrupt end as the flask crashes to the floor. The viewer returns to "real" time and the video begins another cycle of play.

The Wilsons' strong desire to reactivate abandoned spaces extends to the activities of various machines and switchboards. Reel-to-reel tape players—curiously outdated surveillance equipment even when they were last in active use—turn at different speeds. Telephones and video monitors stand at the ready. Fans whir and lights blink. Although no dialogue or voice-over frames the images, clanging, buzzing, and clicking sounds—"like noises in back of your mind"[9]—create an ambient soundtrack whose slightly disconnected relationship to the images suggest that something is always going on behind your back. *Stasi City*'s installation in opposite corners further suggests the Wilsons' interest in activated spaces. Surrounded by pairs of projected images, the viewer remains in constant motion to keep track of the changing images that tug at one's peripheral vision. Viewers can lose themselves in the images only to a degree, however, as the shifting perspectives and juxtaposed camera movements repeatedly draw attention back to the physical act of observing and to one's position in the center.

Sharing its power to mesmerize an audience with cinema, the Wilsons' work is sometimes discussed in relation to directors Alfred Hitchcock, Stanley Kubrick, and Roman Polanski.[10] The Wilsons cite the influence of early- and mid-twentieth-century Russian filmmakers Dziga Vertov and Andrei Tarkovsky and have linked *Stasi City* to "The Zone" in Tarkovsky's *Stalker* (1979), which they admire for its use of carefully chosen shots and the power of suggestion, rather than special effects, to create its potent psychological space.[11] Their noticeably high production values also suggest a cinematic affinity. Consistent with the general direction of video installation in the 1990s, the Wilsons' approach to the medium belies the informal, alternative roots of art video. Like Shirin Neshat, the Wilsons shoot in 16mm film, then transfer to laser disc or DVD for their multi-channel installations (which require high-

Right: *Interview Corridor, Hohenschönhausen Prison,* 1997, C-print mounted on aluminum. Produced in conjunction with *Stasi City*

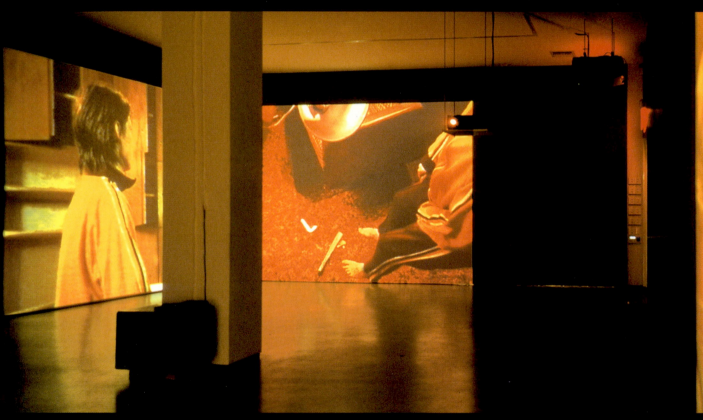

definition three-beam projectors). The camera's disembodied gliding quality results from the use of a dolly for tracking shots, a jib arm (small crane), and a wide-angle 4mm lens, which produces a slightly warped perspective. Together, these tools of the trade help achieve a vision at once impersonal and highly subjective, recalling something of the suspenseful, panic-inducing quality of low-budget horror films, as if seeing through the eyes of a relentless stalker.

Despite this cinematic aesthetic, *Stasi City's* emphasis on the phenomenology and psychology of vision owes a debt to video art of the 1960s and 1970s. Each of the single-channel works described in this section of the catalogue suggests the wide-spread interest in perceptual issues among first- and second-generation video artists. Some of these early works are primarily explorations of the physical characteristics of vision and perspective. Others scrutinize and manipulate vision to draw out implications about the intersection of perspective, subjectivity, privacy, power, and control. Still others consciously appropriate the tools of the dominant culture, using media and surveillance against the institutions and ideologies they represent. *Stasi City* builds on all of these themes. Citing eighteenth-century philosopher and social reformer Jeremy Bentham's design for the now-infamous "Panopticon"—a model prison where all prisoners would be observable by unseen guards at all times—the Wilsons make clear their interest in the complex relationship between vision and power.[12] Positioning the observer in the center of the camera's intrusive, unblinking gaze as it appears in the four projected videos, *Stasi City* makes the viewer an all-seeing agent. At the same time, this central role

prevents the usual cinematic absorption into the image, making the viewer of *Stasi City* aware of his or her own condition of spectatorship. Appropriating the means of oppression, the camera's relentlessly penetrating vision echoes the omnipresent eye of state control, so that seeing and point of view become as much the work's subject as the psychology of the spaces being surveyed.

Though vision is here a central theme, the viewer is, in the end, perhaps most effectively engaged as an active subject through the faculty of imagination. No dialogue, voice-over, or captions frame the images. They lack an explicit narrative, and the uncertainty about the actual purpose of each chamber or device invites speculation. Although exposed to our scrutiny, the Stasi headquarters is revealed, ultimately, as somehow impenetrable, like a dark recess of the human mind that periodically erupts in a chilling flashback. Stimulating our historical, personal, and cultural memory, the projections of images onto the gallery's walls entice us, in turn, to project ourselves into their austere spaces, assigning meanings, making interpretations, spinning fantasies. The insistent vision of *Stasi City* places its viewers at the intersection of sight, memory, history, and imagination.

Jane & Louise Wilson have exhibited extensively in Europe and the United States, including at the Dallas Museum of Art, Texas (2000); the Serpentine Gallery in London (1999); and the Kunstverein Hannover, Germany (1997). *Las Vegas, Graveyard Time* was previewed at the Tate Gallery, London, in the Turner Prize shortlist exhibition (1999), the most prestigious award for a British artist under 40. *Gamma* was shown at the *1999–2000 Carnegie International*, Pittsburgh. ▮

1. For further information on the Stasi's paranoid tactics, see, for example, John O. Koehler, *The Untold Story of the East German Secret Police* (Boulder, Colorado: Westview Press, 2000); Peter Schneider, "The Enemy Within," *The New York Times Sunday Magazine*, January 2001, 32; "Night of a Thousand Stasi," *Living Marxism*, no. 43 (May 1992); *informinec.co.uk/LM/LM43/LM43_Stasi.html;* Robert Uhlig, "German Stasi had red-hot go at dissidents," *www.theage.com.au/news/2001/01/05/FFXZX8WAJHC.html;* and Stephanie Krueger-Blum, "Stasi Uncovered," *www.members.nbci.com/stasihistory.*

2. Beginning in 1991, the newly unified Republic of Germany made the Stasi's once-secret dossiers accessible to individuals by application. Information is still emerging about the identity of informants and suspects. One example is the 2001 legal battle by Olympic Gold Medal figure skater Katarina Witt, a former East German, to keep her file from being released to the press as evidence in a legal judgment.

3. See "In Stereoscopic Vision: A Dialogue Between Jane & Louise Wilson and Lisa Corrin," in *Jane & Louise Wilson*, exhibition catalogue (London: Serpentine Gallery, 1999), 9.

4. See, for example, Neville Wakefield, "Openings: Jane & Louise Wilson," *Artforum* 37 (October 1998): 112–113.

5. In a video exhibition called *Partners*, I included these artists and others, such as The Kipper Kids, the Art Guys, Bob & Bob, and Smith/Stewart, Philadelphia Museum of Art, January 6–April 5, 1998.

6. *Jane & Louise Wilson*, 10.

7. Chrissie Iles, in *Seeing Time: Selections from the Pamela and Richard Kramlich Collection of Media Art* (The San Francisco Museum of Modern Art, 1999): 67.

8. *Jane & Louise Wilson*, 13.

9. *Ibid.*, 14.

10. See, for example, Peter Schjeldahl, "V.I.: Jane & Louise Wilson," in *ibid.*, 4–5.

11. *Ibid.*, 11. They also mention that the floating figure in *Stasi City* refers to Tarkovsky's floating figure in *Solaris* (1975), and that it, too, is an effect achieved entirely on location using a harness, piano wires, and a scaffold to lift and move the figure.

12. *Ibid.*, 8, 12.

Left: Installation view, 303 Gallery, New York, 1997

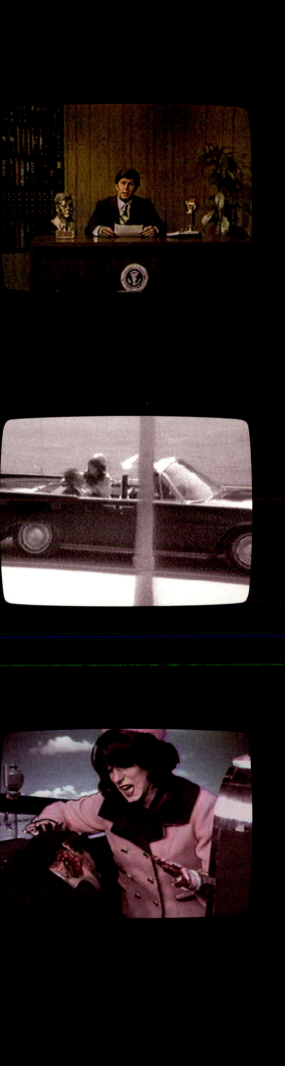

The early history of video art is marked as much by the formation of collectives as by the work of its individual practitioners. Underground and "guerilla" groups such as People's Video Theater, Raindance, and Top Value Television quickly recognized video's potential for serving diverse communities and inserting a radical perspective into broadcast media accounts of social and political events. Ant Farm and T. R. Uthco formed part of this first wave of collectives. Chip Lord and Doug Michels founded Ant Farm in 1968, calling it an "art agency that promotes ideas that have no commercial potential but which we think are important vehicles of cultural introspection."[1] Originally an alternative design practice, it quickly turned to working in video and staging elaborate media spectacles that blurred the boundaries between reality and fiction. One noted event was *Media Burn* (1975), in which a customized Cadillac burst through a wall of flaming television sets. Founded in 1970 by Doug Hall, Jody Procter, and Diane Andrews, T. R. Uthco was a multimedia performance art collective that shared Ant Farm's fascination with public spectacle and their irreverent perspective on American culture. Both groups disbanded in 1978.

Ant Farm and T. R. Uthco came together in 1975 to make *The Eternal Frame,* perhaps their most notorious work. Combining live performance, taped reenactment, and mock documentary, this work revolves around their public restaging of the 1963 assassination of John F. Kennedy in Dallas. They based their simulation on 8mm footage filmed by Abraham Zapruder, a bystander whose primitive record etched itself in the nation's collective memory as the official account of that historic event. Ant Farm & T. R. Uthco's re-creation deliberately blurs the line between fact and fiction. Alternating between color and black and white, the tape interweaves numerous stagings of the shooting with wry commentary by the actors on their performances. Doug Hall, impersonating Kennedy, gives several mock television speeches outlining the premise for his "media death." Scenes of bystanders who have gathered to watch the reenactment underscore the inseparable link between history and its media representation: amateur videographers wield their cameras as though it were the original event and the crowd becomes emotionally involved, cheering, shouting, and crying each time the "President" is shot. In its fascination with the intersection of historical trauma and media spectacle, *The Eternal Frame* serves as an interesting precedent to the Wilsons' *Stasi City.* Bracketing the Cold War, Kennedy's assassination, and the Stasi's downfall are events of mythic proportion that represent extreme assaults on political authority and their underlying ideologies. ▮

1. *Artists' Video: An International Guide,* ed. Lori Zippay (New York: Cross River Press, 1991): 25.

Ant Farm & T. R. Uthco

Chip Lord
Born in Cleveland, Ohio, 1944
Lives in Santa Cruz, California

Doug Michels
Born in Seattle, Washington, 1943
Lives in Houston, Texas

Doug Hall
Born in San Francisco, California, 1944
Lives in San Francisco

Jody Procter
Born in Boston, Massachusetts, 1943
Died Eugene, Oregon, 1998

The Eternal Frame, 1975
23 minutes 50 seconds,
black and white and color, sound

Distributed by Electronic Arts Intermix, New York

James Byrne

Born in St. Paul, Minnesota, 1950
Lives in St. Paul

One Way, 1979

7 minutes 54 seconds,
black and white, sound

Distributed by Electronic Arts
Intermix, New York

James Byrne began working with video in 1972 at the Minneapolis College of Art and Design, where he studied with Peter Campus. Byrne shared Campus's interest in exploring the physical properties of perception and in actively involving the viewer in the work. He was also interested in Merce Cunningham's experimental dance and the growing involvement of visual artists in body-based performance art. Byrne generally appeared in his works carrying out carefully structured, but relatively simple, actions that directly addressed and sometimes physically manipulated the camera. Combining elements of humor and confrontation, these taped performances explored the nature of the video medium and challenged viewers' perceptions of space and time. Around 1975, Byrne began making video installations as a way to structure the viewing experience more actively. These works frequently placed the observer in unusual positions, such as lying on the floor beneath a monitor that showed the artist throwing tennis balls at the camera lens. Byrne describes wanting "to create a situation where the viewer . . . could easily slip into feeling as if they were in the monitor and those things that were happening were happening to them although they were still standing outside."[1]

One Way marks a transition in Byrne's work from body-based performance to landscape (loosely speaking), a subject that along with dance and architecture became central to his video work in the 1980s. Based on the simple premise of a walk around the neighborhood, the tape captures an intensely physical interaction with the environment. Byrne collides the camera with various surfaces, banging it into trees, slapping it along a chain link fence, scraping it on the sidewalk. Extreme close-ups transform everyday objects into abstract patterns. The camera's microphone records a soundtrack of clanging, grating, scraping, and tapping, transforming the supposedly precious video equipment into a sound-producing instrument and underscoring the camera's physical engagement with its subject. As an extension of the artist's unseen body, the camera yields a kinesthetic record that places the viewer in the artist's shoes, making an interesting comparison with the physicality of the roving lens in *Stasi City*. But unlike the Wilsons' installation, the use of the camera in *One Way* has an irreverent quality, sometimes verging on slapstick (albeit deadpan) as it inevitably collides with approaching trees and signs (including a "one way" sign). Like the best of early video art, this work transforms a formal exercise into a rich investigation of both external reality and its own means. It makes a disorienting merger of the optical and the tactile—"feeling" the world with its "eye." ▌

1. Marie Cieri, "James Byrne's Video Environments," *Afterimage* 7, no. 7 (February 1980): 4.

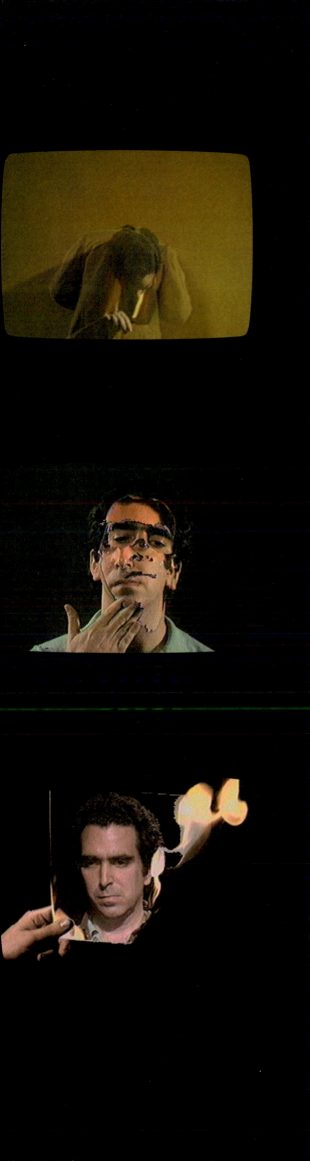

One of the central figures in early video art, Peter Campus came to the medium in 1971 after nearly a decade working in film and television production. His early video installations incorporated mirrors, shadows, and live, closed-circuit video projections of viewers. Campus was interested in bridging the distance between the spectator and the spectacle. But in contrast to commercial television and film practice, he rejected the idea of a seamless identification between viewer and image. Campus's disorienting installations introduced multiple images of observers who interacted with the installation components to produce and reconcile various representations of themselves. In 1978, Campus stopped working in video and turned to projected slide installations showing greatly enlarged images of faces altered by strong light and shadow. During the 1980s, he turned to landscape photography, at first black-and-white "straight" works and later computer-manipulated color images, with the relationship between light and shadow continuing as a central motif. In the late 1990s, Campus returned to video and to the psychology of perception that marked his earliest work.

Concurrently with his early video installations, Campus made single-channel tapes to be shown on monitors. *Three Transitions* belongs to a series of short works made in the mid-1970s featuring Campus as the primary performer and exploring transformations of the human form on perceptual and metaphorical levels. In each of the surprising "self-portraits" in *Three Transitions*, Campus plays with the distinction between an interior and exterior self. The first piece uses two cameras positioned on opposite sides of a wall of paper. Dressed in a camel-colored jacket against a similarly colored background, Campus appears to cut himself open and climb through his body. In the second piece, Campus applies makeup to his face. In real time, using Chroma-Key technology,[1] each dab of make-up erases part of the image, eventually revealing another live image of his face behind the first one. In part three, Campus holds a mirror reflection of his face at arm's length. He sets the live image on fire and proceeds to burn it as if it were a sheet of paper. Embracing the advanced technology and high production values of the television studio, *Three Transitions* exemplifies Campus's grounding of the metaphysical issues of illusion and reality, self-awareness and identity in the medium's capabilities and the phenomenology of perception. ▌

1. The Chroma-Key process allows areas of an image to be isolated based on their color, then "keyed" out and replaced with another image or color.

Peter Campus
Born in New York, New York, 1937
Lives on Long Island, New York

Three Transitions, 1973
4 minutes 53 seconds, color, sound

Distributed by Electronic Arts Intermix, New York

Dan Graham
Born in Urbana, Illinois, 1942
Lives in New York, New York

Performer/Audience/
Mirror, 1977
22 minutes 52 seconds,
black and white, sound

Distributed by Electronic Arts
Intermix, New York

Dan Graham began working with video in 1972, using architectural settings, mirrors, and live and tape-delayed closed-circuit feedback to explore the physical, cognitive, and social aspects of vision. He had previously used Super 8 and 16mm film in his investigation of "visual consciousness," making a series of split-screen works between 1969 and 1974. In these films, Graham used two cameras to complicate the relationship between the viewpoints of camera and spectator as the filmmakers/performers moved in space while recording each other, or as one camera moved while another remained fixed. Graham's interest in questions of perception and subjectivity can be traced back to his earlier "journalistic" text-based pieces and his color photographs of the rapidly expanding suburban development surrounding New York City. These bodies of work helped define mid-1960s Conceptual Art strategies by documenting external social systems while simultaneously investigating their own status as art objects. Beginning in the mid-1970s, Graham's environmental sculptures—glass and metal pavilions set in gardens, on rooftops, or in exhibition spaces—have continued these reflexive concerns: viewers experiencing the complex interaction of architectural space, external view, reflective glass, and other participants are led to a heightened awareness of their role as perceiving subjects.

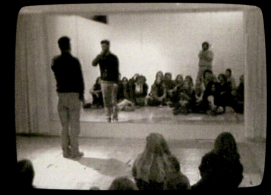

Performer/Audience/Mirror records a live performance in 1977 at De Appel in Amsterdam.[1] Graham stands before a seated audience that faces itself in a wall-sized mirror behind the artist. In the first of four sequences, while walking around the space between audience and mirror, he continuously describes his every external movement and the attitudes he believes his body language conveys. In part two, he continues facing the audience members and constantly narrates their external behavior and appearance. In part three, he turns his back to the audience and describes his movements, appearance, and attitude as reflected in the mirror. In part four, with back still turned to the audience members, he describes them by their reflection. Graham envisaged that, faced with its reflection, the audience would instantly recognize itself as a collective—a public body—and that this would offset the power imbalance of the performer's freedom to change perspective and to objectify the audience through his description. Moreover, audience members had the power to affect the artist's narration of their behavior by their smiles and body adjustments, often occurring in response to Graham's description, thereby adding to the complexity of this interweaving of subject and object; cause and effect; and past, present, and future. ▌

1. In conversation with the author on October 16, 2001 Graham confirmed that this tape records the De Appel performance and described how a related work, *Performance/ Audience/Sequence,* performed in 1975 at Video Free America, has sometimes been mistaken for it.

Mary Lucier began working with video in 1972 after a decade of working in sculpture, photography, and performance. Making singe-channel tapes and multi-channel installations, Lucier used video technology to extend her interests in the formal elements of time, space, sound, and light. Rather than turn the camera on herself like many of her fellow video pioneers, Lucier took the medium itself as her subject, which she explored in various processes that deliberately pushed the equipment beyond its optimum capabilities. During the 1980s and 1990s, Lucier's installations became increasingly complex environments of images, sounds, and objects, which she has described as "at once cinematic, sculptural, and theatrical."[1]

The themes that characterize her installations—memory, mortality, and the use of light as a pivotal point in the relationship between nature and technology—are also evident in her early work. *Bird's Eye* belongs to a series of burn pieces that Lucier made throughout the seventies. Having been warned never to turn her camera directly toward the sun so as not to damage its vidicon tube, Lucier recalls that being the first thing she did, recording the sun's rise for thirty minutes at a time over seven days (*Dawn Burn,* 1975).[2] She soon began to aim lasers at the camera lens as another way to scar the tube's photosensitive surface. Accompanied by her former husband Alvin Lucier's electronic score, *Bird and Person Dying,* which combines bird twitters and high-pitched electronic tones, *Bird's Eye* records the effect of laser burn. Abstract and mysterious, the work presents a light spot surrounded by slowly changing moiré patterns of luminescent white lines against a dark ground. Together the images and sounds evoke approaching dawn, but the anxious, almost eerie effect of their pairing also suggests an altered state of mind. Likening the camera lens to the human retina, Lucier has described the traumatizing of the tube by light as "a metaphor about birth and death, about creation and destruction being enacted in the same moment in a single event, which is the act of making art."[3] *Bird's Eye* adds to this union of illumination and decay a perceptual ambiguity about whether one is looking into one's own retina or deeply into space. ▌

1. See Electronic Arts Intermix Online Catalogue at www.eai.org.

2. Nicholas Drake, "Texture, Grace, and Drama: An interview with Mary Lucier," in *Mary Lucier,* ed. Melinda Barlow (Baltimore: The Johns Hopkins University Press, 2000), 233–4.

3. Peter Doroshenko, "Mary Lucier," in *Mary Lucier,* 227.

Mary Lucier
Born in Bucyrus, Ohio, 1944
Lives in New York, New York

Bird's Eye, 1978
10 minutes 28 seconds,
black and white, sound

Distributed by Electronic Arts Intermix, New York

Branda Miller
Born in Milwaukee, Wisconsin, 1952
Lives in Averill Park, New York

L. A. Nickel, 1983
8 minutes 33 seconds, color, sound

Distributed by Electronic Arts Intermix, New York

Using video as a tool for social change, Branda Miller trains her camera on subjects pushed to the margins of society, such as drug addicts and the homeless. Her work reflects the legacy of "street tapes" and other guerilla tactics that flourished among the first generation of video makers. Examples include Les Levine's *Bum* (1965), which consists of interviews with winos on New York's Bowery, and Frank Gillette's five-hour 1968 documentary of street life on New York's Saint Mark's Place, the unofficial center of East Coast hippie culture.[1] Miller combines this street aesthetic and activist spirit with an experimental approach to her medium, including more sophisticated editing, layered montages of images, evocative soundtracks, and electronically processed abstract imagery.

In 1980, while filming *L. A. Nickel,* Miller lived in a loft on Los Angeles's Skid Row. Located across the street from the downtown police station, she observed first-hand the constant harassment of street people. As she describes it, "I spent hours gazing out of the window with a feeling of disbelief as I watched with horror the spectacle of the police apparatus combating displaced people, 'to clean up the area' for urban development."[2] Hidden from view, and monitoring the street activity with a video camera and zoom lens, Miller conceived of her secret center of observation as a Panopticon, eighteenth-century philosopher and social reformer Jeremy Bentham's radially designed prison in which a central guard tower allowed a single gaze to continuously oversee all activity. Miller also hid radio microphones on "audio agents" who ventured out onto street to gather sound. To the repeated, syncopated, and slowed-down spoken phrase "I'm too f...d up," Miller shows scenes of men and women hanging out, fighting, doing deals, and being arrested. A second sequence, set to dramatically orchestrated piano music and an ominous rhythmic booming sound,[3] shows the view through the windshield of a car rolling slowly down the street at night. Street lamps and police car lights dissolve the scene into a play of abstract patterns. Presenting a nightmarish vision of social control aimed at the most defenseless targets, *L. A. Nickel* also suggests that the strategy of surveillance can be used to serve artistic creation and free speech. ▮

1. For a discussion of this early history, see Deirdre Boyle, "A Brief History of American Documentary Video," in *Illuminating Video: An Essential Guide to Video Art,* ed. Doug Hall and Sally Jo Fifer (New York: Aperture, 1990), 51–69.

2. Branda Miller, "The Art of Invasion," in *Surveillance: An Exhibition of Video, Photography, Installations,* exhibition catalogue (Los Angeles: Los Angeles Contemporary Exhibitions, 1987), 6.

3. Set at the pace of a human heart, the repeated booming records the slamming of Miller's loft door, which she described as the division between inner and outer worlds, between enclosure in a protected space and entry into a zone of danger. In conversation with the author, August 29, 2001.

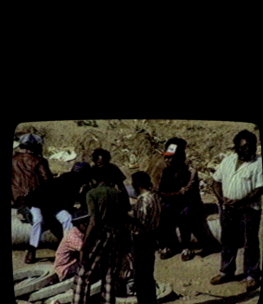

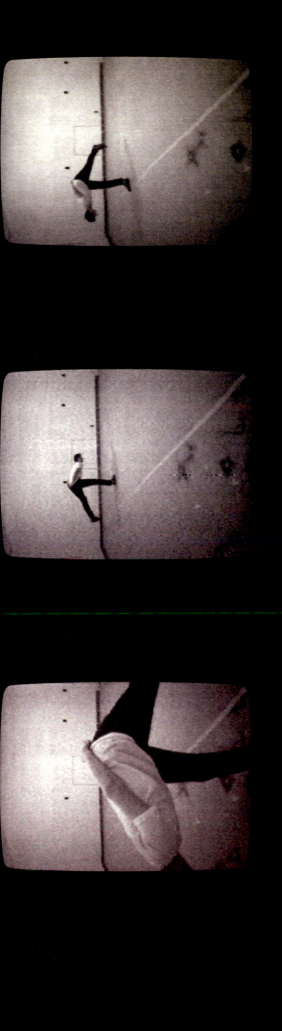

In the late 1960s, inspired by the experimental dance of Merce Cunningham and Meredith Monk, Bruce Nauman began to consider every aspect of the artist's time spent in his studio as worthy of sustained exploration. Performed alone before the stationary camera, activities such as pacing, jumping, and stamping form the basis for some two dozen films and tapes Nauman made in 1968–69. Nauman first used 16mm film, finding the equipment readily available among his San Francisco peers; upon briefly moving to New York in late 1968, he began using video. The more easily manipulated video camera led to working with disorienting angles that became signature elements in his work. In *Slow Angle Walk (Beckett Walk)* Nauman performs a series of stylized steps around the studio before a video camera turned ninety degrees on its side. With hands clasped behind his back, he kicks one leg out stiffly in front of him at a right angle, pivots a quarter turn, then falls forward onto it with a thud. His back leg then sticks out behind, with his upper body bending forward. Swinging the back leg forward, he begins the sequence again.

The work's title suggests a literary source of inspiration. Nauman had read the work of Irish novelist and playwright Samuel Beckett extensively in 1966 and was particularly interested in his character Molloy's repetitive and often useless activities. *Slow Angle Walk (Beckett Walk)* alludes to a passage in *Molloy* (1951) describing the character's journey to someone's house. Hobbling stiff-legged on his crutch, he makes slow, nonlinear progress. As Nauman recalls, "The body movements are like exercises—bending, rotating, raising one leg, going on and on. It's a tedious, complicated process to gain even a yard."[1] Nauman's performance also involves great concentration, raising the mundane task to a quasi-athletic event. Adding a further level of rigor, Nauman mapped out in advance the precise pattern of movements.[2] Beginning at the back of the room, three step-turns to the right and three step-turns to the left advance him two paces. Eventually, he continues past the camera, disappearing out of sight for several minutes. Mannered, off-kilter, and repeated for nearly an hour (the duration of a standard videotape), the performance transforms the ordinary task of walking into something both funny and strange. Acknowledging that watching the work is as much an endurance event as making it, Nauman has said, "I wanted the tension of waiting for something to happen, and then you should just get drawn into the rhythm of the thing. . . ."[3] ▊

1. In Jane Livingston, "Bruce Nauman," in *Bruce Nauman, Works from 1965 to 1972*, exhibition catalogue (Los Angeles: Los Angeles County Museum of Art, 1972), 26.

2. *Untitled (Study for "Slow Angle Walk")*, plate 29, in *Bruce Nauman*, exhibition catalogue (Minneapolis: Walker Art Center, 1994). See also Gijs van Tuyl's discussion of Nauman's and Beckett's interest in mathematical and geometrical questions, "Human Condition/Human Body: Bruce Nauman and Samuel Beckett," in *Bruce Nauman*, exhibition catalogue (London: Hayward Gallery, 1998), 69.

3. Livingston, "Bruce Nauman," 26.

Bruce Nauman
Born in Fort Wayne, Indiana, 1941
Lives in Galisteo, New Mexico

Slow Angle Walk (Beckett Walk), 1968
55 minutes, 51 seconds, black and white, sound

Distributed by Electronic Arts Intermix, New York

Marcel Odenbach

Born in Cologne, Germany, 1953
Lives in Cologne

*I Do the Pain Test
(Ich mache die
Schmerzprobe),* 1984

6 minutes 25 seconds, color,
sound

Distributed by Electronic Arts
Intermix, New York

Part of the first generation of German video artists,
Marcel Odenbach has made tapes and installations since
the mid-1970s. From the beginning, his multimedia
approach—combining monitors, projections, music,
objects, and wall texts—placed him at the forefront of
installation practice.[1] Odenbach's single-channel tapes
are also characterized by montage—juxtaposing
imagery from classic movies, archival films, newsreels,
and material he has recorded himself—set to suggestive
musical soundtracks. Political and social in nature, his
works examine subjects of race, sexuality, displacement,
and totalitarianism. Like fellow German artist Klaus vom
Bruch, Odenbach's work considers the effect of historical
events and their media representation on our individual
identities and our perceptions of the present. Rejecting
polemics or didacticism, Odenbach undermines the
notion of achieving an objective analysis of culture:
"Art does not transmit information. It is not concerned
with the representation of the indexical real or with
efficient communication. . . . On the contrary, in its
critical mode it works to uncouple the habitual rela-
tions between meaning and referent, exposing rather
the bathos of an essential incommunicability between
self and other."[2]

In *I Do the Pain Test,* Odenbach compares and
contrasts brute physicality with high and low culture
to address questions of male identity and authority.
The work begins with a severely cropped view of a man
changing into workout clothes. The limited perspective
(mostly from the knees down) and a soundtrack of
rhythmic drumming and chanting add a sense of
mystery, even foreboding. As the man uses various
weightlifting machines, close-ups of his straining
muscles are overlaid with images of Baroque garden
statuary and architectural decoration, and with footage
from Hollywood action films (including Gene Hackman
in *The French Connection*). Throughout, the sound of
the weights slapping down and a repeated cracking of
a whip underscore the quality of ritual and masochism
inherent in body building and, by implication, in the
actions of our male heroes. At the same time, the self-
control displayed by the athlete parallels the artist's
control of our vision by the tightly focussed views and
inserted panels of found images. Forced uncomfortably
close to the subject in this confrontational work, the
viewer becomes something of a voyeur, and the sense
of discipline and punishment translates rather fluidly
to a suggestion of totalitarian authority. ▋

1. While known primarily in Europe where he is one of the leading video artists,
Odenbach participated in *Video Spaces: Eight Installations* (1995) at the Museum of
Modern Art, New York. In 1998-99, the New Museum of Contemporary Art, New York,
held a retrospective of his work.

2. Quoted in Kobena Mercer, "Knowing Me, Knowing You: Video Art as a Practice of
Hybridization," in *Marcel Odenbach,* exhibition catalogue (New York: New Museum of
Contemporary Art, 1998), 31.

Nam June Paik began making the first artist's videotapes in October 1965, on the same day that he used some of his money from a John D. Rockefeller III Foundation grant to purchase one of the first Sony Portapak cameras sold in the United States. Paik had already experimented with magnets and electronic processors to distort broadcast signals on the television monitor. He soon began to apply these methods to his own videotapes, subjecting recorded and found footage to fragmentation, repetition, coloration, and other means of abstraction. At his first New York solo exhibition in 1965,[1] Paik met filmmaker and video artist Jud Yalkut. Based on their shared interest in the interface of film and video, the two began to collaborate in the electronic manipulation of images and in the appropriation of popular sources. One of Paik and Yalkut's published goals was "the trans-mutation of popular cliché images familiar to any contemporary consciousness, reiterated and metamor-phosed beyond their popular meanings into abstraction."[2]

Videotape Study No. 3 is based on pre-taped and live press conferences by President Lyndon Johnson and New York City Mayor John Lindsay. Appropriating segments of these events from broadcast television, Paik and Yalkut altered them "electronically and manually by stopping the tape and moving in slow and reversed motion, and by repeated actions."[3] The results far exceed Paik and Yalkut's published claim to turn popular clichés into abstractions. The stuttering and deformed performances by Johnson and Lindsay make a mockery of political authority. Using the tools and imagery of mass-media news reportage, but denying it the usual semblance of objectivity, the work exposes the media as an apparatus of state control. As one writer points out, the visual distortions of the political figures paral-lel their distortions of fact, serving as simultaneous indictments of politics and of broadcast television.[4] The influence of *Videotape Study No. 3* and similar early works by Paik and Yalkut can be seen in areas as diverse as video art by Dara Birnbaum, Marcel Odenbach, and Pipilotti Rist; in popular music video; in the increasingly rapid jump-cutting of commercial film and television; and in Hip Hop music's practice of "sampling" a broad range of found audio sources. ▌

1. *Nam June Paik—Electronic Art,* Galeria Bonino, New York, November 23–December 11, 1965.

2. Published in *Film Culture-Expanded Arts Special Issue* 43 (Winter 1966) as quoted in "Jud Yalkut" in *Video Art: An Anthology,* ed. Ira Schneider and Beryl Korot (New York and London: Harcourt Brace Jovanovich, 1976), 147.

3. *Ibid.*

4. John Hanhardt, *The Worlds of Nam June Paik,* exhibition catalogue (New York: Solomon R. Guggenheim Museum, 2000), 214.

Nam June Paik
Born in Seoul, Korea, 1932
Lives in New York, New York

Jud Yalkut
Born in New York, New York, 1938
Lives in Dayton, Ohio

Video Tape Study No. 3, 1967–69
3 minutes 51 seconds, black and white, sound

Distributed by Electronic Arts Intermix, New York

Charlemagne Palestine
Born Charles Martin in New York,
New York, 1947
Lives in Brussels, Belgium

Running Outburst, 1975
5 minutes 56 seconds,
black and white, sound

Distributed by Electronic Arts
Intermix, New York

Made the same year as his *Internal Tantrum* (see page 69), Charlemagne Palestine's *Running Outburst* continues the artist's use of sound and motion in intense performances videotaped while alone in his studio. In this work, however, Palestine remains invisible behind the camera and the viewer appears to see through his eyes. To the sound of footsteps, the camera's view begins to move around the artist's loft. Then Palestine begins a guttural chant. As volume and pitch rise, his pace picks up, sending our perspective careening around the space and making us acutely aware of his heightened emotional state and physical exertion (added to by the thirty-plus pounds of video equipment he carries on his back). Speaking of himself in "mythic" third person to describe his fusion of performance, sound, and video, Palestine has said, "the animal performs sounds and movement in space documented by video. . . . Through the eyes of the Minotaur [we see] . . . the monster's own view of his predicament."[1]

By referring to himself as the Minotaur—in Greek mythology the bull-headed man shut up by King Minos in the labyrinth constructed by Daedalus in Crete —Palestine sheds light on his quasi-religious, ritualistic conception of his work and his use of animals as symbolic objects. In *Running Outburst,* the strange sight of Palestine's signature stuffed animals sitting against columns adds to the unnerving quality of the piece. As he comments, "My performances were about the energy of my body and the animals were always there. They were a sort of mystery. No one ever really knew why they were there. And I never explained why. During that period I was the subject and they were my companions. Sort of spectators from another dimension."[2] Using body and voice to articulate a cathartic personal drama,[3] Palestine's *Running Outburst* invests the experience of space with an intensely physical and psychological dynamic. ▌

1. E-mail correspondence with the author, July 5, 2001.

2. "Charlemagne Palestine, A Talk with Anselm Staider," *Flash Art* 121 (March 1985): 28.

3. Palestine used the statement "using body and voice to articulate personal drama" in his two-page spread in *Video Art: An Anthology,* ed. Ira Schneider and Beryl Korot (New York and London: Harcourt Brace Jovanovich, 1976), 100–01.

In the late 1960s and 1970s, Richard Serra's lead and steel sculptures established him as a leading Post-Minimalist artist. At the same time, Serra began working with film and video, making some two-dozen pieces between 1968 and 1979. Serra's films, which he began first, tended to reflect his sculptural interest in process and repetition. His videos, which he began making in 1971, tended toward structural analyses of mass media.

Television Delivers People (made with Carlotta Schoolman) presents one of early video art's most direct attacks on the insidious nature of commercial broadcast television. Using the seductive manner of TV advertising, the work asserts Serra's contention that, contrary to general belief, television viewers are not consumers of a product but are themselves the product of television. A relentless flow of terse subversive messages, made all the more ironic by a jazzy daytime-TV sound track, mimics televisions' onslaught of commercial propaganda: "Television delivers people to an advertiser. . . . You are delivered to the advertiser, who is the customer. He consumes you. . . ."[1] Serra formed the script by assembling excerpts from published papers given at an academic media symposium. The work was first broadcast as a station sign-off in Amarillo, Texas, and was subsequently shown on other broadcast television stations, including Chicago's WTTW. As motivation for exposing the mechanism of corporate control masquerading behind entertainment television, Serra has said, ". . . television in this country had a stranglehold on anybody who wanted to make video. If you want people to see work, you have to contend with those structures of control; and those structures of control are predicated on the capitalistic status quo. I simply decided to make that explicit."[2]

Surprise Attack, made the same year, focuses on Serra's hands tossing a piece of lead back and forth. The activity sets the pace for an insistently rhythmic monologue about meeting an attacker in one's home. Reciting text from political economist Thomas Schelling's *Strategy of Conflict,* a 1961 text on game theory and its implications for human relations, Serra addresses the dynamics of fear and self-defense. Beginning with simple questions such as "If you hear a burglar downstairs, should you pick up a gun or not pick up a gun?" the reasoning devolves to self-defeating loops that paralyze action ("He thinks we think that he thinks we think that he thinks we won't attack, so . . . "). This work has been interpreted as a metaphor for Cold War defensiveness and paranoia.[3] ∎

1. For the entire text see *Video Art: An Anthology,* ed. Ira Schneider and Beryl Korot, (New York and London: Harcourt Brace Jovanovich, 1976), 100–01.

2. Annette Michelson, Richard Serra, and Clara Weyergraf, "The Films of Richard Serra: An Interview," in *Richard Serra: Writings, Interviews* (Chicago: University of Chicago Press, 1994): 74.

3. Video Data Bank online catalogue: www.vdb.org.

Richard Serra
Born in San Francisco, California, 1939
Lives in New York, New York

Television Delivers People, 1973
6 minutes 37 seconds, color, sound

Surprise Attack, 1973
1 minute 56 seconds, black and white, sound

Both tapes distributed by Video Data Bank, Chicago

Steina

Born Steinunn Briem Bjarnadottir
in Reykjavik, Iceland, 1940
Lives in Santa Fe, New Mexico

Summer Salt, 1982
color, sound

Sky High, 2 minutes 45 seconds

Low Ride, 3 minutes

Somersault, 5 minutes 15 seconds

Rest, 2 minutes 17 seconds

Photographic Memory,
5 minutes 25 seconds

Distributed by Electronic Arts
Intermix, New York

Together with her husband Woody Vasulka, Steina (as
she is known professionally) has been at the forefront
of video experimentation since the late 1960s. Trained
as a classical violinist, Steina played with the Icelandic
Symphony Orchestra before moving to New York in 1965.
In 1969, the Vasulkas began to work in video, making
collaborative pieces that investigated the interface of
image, sound, and electronic technology. As recent
immigrants to the United States during a time of wide-
spread social upheaval, and coming to video art in its
infancy, the Vasulkas approached the medium with a
utopian spirit. Working with a community of engineers,
they designed equipment to make technology available
for new artistic and community applications and, in 1971,
they co-founded The Kitchen, an experimental multimedia
arts center in New York City. Steina's solo work, pursued
especially from the mid-1970s on, demonstrates her
interest in space and time as central subjects.

In 1980 the Vasulkas moved to Santa Fe,
New Mexico, where Steina made *Summer Salt.* Made with
a color camera that she started using in 1977, this tape
continues her exploration of the phenomenology of space,
now with the Southwestern landscape as a subject and
reintroducing the human body as an active agent. Each
of *Summer Salt's* five vignettes employs a different cam-
era position and movement. In *Sky High,* Steina mounts
a camera with a fish-eye lens on top of a moving vehi-
cle. The lens points at an attached mirrored sphere that
recalls one used in *Machine Vision* (the "Spiratone"
bird's-eye lens attachment). As she drives, the camera
records a nearly 360-degree distortion of sky and
ground, suggesting global circumnavigation. In *Low
Ride,* the camera is tied to the front bumper of a car as
it drives through empty lots and fields. As in James
Byrne's *One Way,* the video and audio tracks capture an
extremely physical record of the camera's direct contact
with its environment. *Somersault* presents a dizzying
record of constant motion as Steina passes the camera
hand to hand, between her legs, over her head, and
around her back. Again using the fish-eye lens and
Spiratone bird's-eye attachment, the camera offers a view
of itself, Steina's body, and the surrounding landscape
wrapped around its lens. *Rest* allows the camera—and
the viewer—some respite after the prior three pieces.
Recording the view from a hammock, the camera swings
back and forth as it slowly scans upward to colorized and
abstracted trees and sky. *Photographic Memory* layers
images of trees in different seasons. Interweaving color
with black and white, and stills with moving images, all
set to an eerie droning tone, the tape suggests a tension
between perception and memory. ▍

The Space Between the Teeth belongs to a group of works Bill Viola made in 1976 called *Four Songs,* which also includes *Junkyard Levitation, Songs of Innocence,* and *Truth Through Mass Individuation.* That year, after stints in the early and mid-seventies working as an assistant to Nam June Paik and Peter Campus and studying with avant-garde composer David Tudor, Viola became artist-in-residence at New York's WNET/Thirteen Television Laboratory, a public television center that supported experimentation in video by giving artists access to broadcast-quality equipment. Using the TV Lab's new computer-controlled editing system, Viola was able to take his investigations of perception and consciousness to a new level of sophistication. For *The Space Between the Teeth* (which builds on his *Tape I* from 1972) he worked out mathematically derived time relationships that govern the alternation between two different scenes—sets of imagery that represent inner and outer realities and, ultimately, the transcendence of this duality.

At the beginning of the tape, Viola enters a white cinderblock room and takes a drink from a utility-sink faucet, then settles into a chair and stares into the camera. After a silent minute, he suddenly yells. A second yell half a minute later sends the camera traveling unsteadily backwards down a long hallway. Several yells at diminishing intervals punctuate the camera's journey until it comes to rest at the other end of what it reveals as an industrial basement corridor. Another yell sends the camera hurtling back down the passageway toward the artist, stopping at his mouth. Then it quickly retreats. This sequence repeats, with the camera moving a shorter distance away and coming closer to the artist's face each time. A brief cutaway introduces a mundane domestic kitchen, which reappears in increasing frequency and duration in counterpoint to the decreasing yelling-face shots. A final yell brings the camera looking right into the artist's mouth between his teeth. Back in the kitchen, which by contrast radiates calm stasis, the artist enters, washes a few dishes, and leaves the water on. The camera continues its slow, steady movement forward to a close-up of the running faucet. After a pause, the yell and hallway reappear, now as a black-and-white photograph that drops away to float on a body of water. The sound of an approaching ship is heard; its wake washes the photo out of the frame. Using the camera as an observing eye capable of revealing subjective and objective reality, *The Space Between the Teeth* presents reality as a nonlinear layering of the past and the present, and of external perception and inner consciousness. ▌

Bill Viola
Born in New York, New York, 1951
Lives in Long Beach, California

The Space Between the Teeth, 1976
9 minutes 10 seconds, black and white and color, sound

Distributed by Electronic Arts Intermix, New York

General Reading List

American Landscape Video: The Electronic Groove. Exhibition catalogue. Pittsburgh: The Carnegie Museum of Art, 1988.

Battcock, Gregory, ed. *New Artists Video: A Critical Anthology.* New York: E. P. Dutton, 1978.

Cappellazzo, Amy. *Making Time: Considering Time as a Material in Contemporary Video and Film.* Exhibition catalogue. Florida: Palm Beach Institute of Contemporary Art, 2000.

Gigliotti, Davidson, ed. *The Early Video Project.* 2000. Website: http://davidsonsfiles.org/

Hall, Doug, and Sally Jo Fifer, eds. *Illuminating Video: An Essential Guide to Video Art.* New York: Aperture Foundation, 1990.

Hanhardt, John G., ed. *Video Culture: A Critical Investigation.* New York: Visual Studies Workshop Press, 1986.

Hanley, JoAnn, and Ann-Sargent Wooster. *The First Generation: Women and Video 1970–75.* Exhibition catalogue. New York: Independent Curators Incorporated, 1993.

Huffman, Kathy Rae. *Video: A Retrospective.* Exhibition catalogue. California: Long Beach Museum of Art, 1984.

London, Barbara. *Video Spaces: Eight Installations.* Exhibition catalogue. New York: The Museum of Modern Art, 1995.

Lovejoy, Margot. *Postmodern Currents: Art and Artists in the Age of Electronic Media.* Ann Arbor and London: UMI Research Press, 1989.

The Luminous Image (Het Lumineuze Beeld). Exhibition catalogue. Amsterdam: Stedelijk Museum, 1984.

Renov, Michael, and Erika Suderberg, eds. *Resolutions: Contemporary Video Practices.* Minneapolis and London: University of Minnesota Press, 1996.

Rush, Michael. *New Media in Late 20th-Century Art.* London and New York: Thames and Hudson, 1999.

Schneider, Ira, and Beryl Korot, eds. *Video Art: An Anthology.* New York and London: Harcourt Brace Jovanovich, 1976.

Seeing Time: Selections from the Pamela and Richard Kramlich Collection of Media Art. Exhibition catalogue. California: San Francisco Museum of Modern Art, 1999.

Video Art. Institute of Contemporary Art. Exhibition catalogue. Philadelphia: University of Pennsylvania, 1975.

Zippay, Lori, ed. *Artists' Video: An International Guide/ Electronic Arts Intermix.* New York: Cross River Press, 1991.

Video Distributors' Websites

Electronic Arts Intermix: www.eai.org

Montevideo (Netherlands Media Art Institute, Montevideo/ Time Based Art): www.montevideo.org

The Kitchen: www.thekitchen.org

Video Data Bank: www.vdb.org

Vtape: www.vtape.org

Index

Production Credits

Sip My Ocean
Director, Editor, Camera, Cast, Sound: Pipilotti Rist; Sound: Anders Guggisberg, cover version of the song 'Wicked Games" by Chris Issac; Vocals: Pipilotti Rist; Camera and Cast: Pierre Mennel; Production Assistant: Nadia Schneider

Rapture
Director: Shirin Neshat; Director of Photography: Ghasem Ebrahimian; Script: Shirin Neshat and Shoja Youssefi Azari; Producer, Morocco: Hamid Farjad; Producer, U.S.: Bahman Soltani; Music and Sound Design: Sussan Deyhim; Editors: Shirin Neshat, Shoja Youseffi Azari, Bill Buckendorf; Production Manager, Morocco: Jane Loveless; Production Manager, U.S.: Tamalyn Miller; Costume Designer: Noureddine Amir; Still Photography: Larry Barns; Camera Assistant: Mustapha Marjane; Key Grip and Dolly: Abdelaziz Makramani; Second Grip: Abderahmane Fahim; Assistants to Director: Mamoun Chentit, Zineb Charhourh, Fatima Bahmani, Mustapha Sbia.

Stasi City
Producers and Directors: Jane & Louise Wilson; Coordinator: Rudiger Lange; Cameraman: Alistair Cameron; Assistant Cameraman: Gerde Breite; Photography: Jane & Louise Wilson, Justin Westover; Sound Operator: Andreas Koppen; Electrical: John Taylor; Driver: Stephanie Umbreit; Lighting: Wolfgang Franke.

Image Credits

All images courtesy of Electronic Arts Intermix, with the exception of the following:

Will Brown, courtesy The Fabric Workshop and Museum, Philadelphia, Pennsylvania: pp. 32–33; 34–35

Theo Coulombe, courtesy 303 Gallery, New York, New York: p. 82

Lenon, Weinberg, Inc., New York, New York (Collection of ZKM Museum für Neue Kunst, Karlsruhe, Germany): p. 19

Robert Lifson, © The Art Institute of Chicago, Illinois: p. 58

Courtesy Lisson Gallery, London, England: p. 81

Beckett Logan, courtesy Howardena Pindell: p. 70

Fred Londier, courtesy of Ronald Feldman Fine Arts, Inc., New York, New York: p. 8

Luhring Augustine Gallery, New York, New York: p. 31

B. Merrett, Musée de beaux-arts de Montréal, Canada: p. 36

© 1999 Shirin Neshat. Photos by Larry Barns. Courtesy Barbara Gladstone Gallery, New York, New York: pp. 54, 55, 56, and 57

Nam June Paik Studio: p. 18

Kira Perov, courtesy James Cohan Gallery, New York, New York: p. 20

© 1967 (Renewed 1995) The Sixth Floor Museum at Dealy Plaza, Dallas, Texas. All rights reserved: p. 24

Holly Solomon Gallery, New York, New York: p. 16

303 Gallery, New York, New York: pp. 20, 77, and 78–79

© 2001 The Andy Warhol Museum, Pittsburgh, Pennsylvania, a museum of Carnegie Institute: p. 3

Katherine Wetzel, © Virginia Museum of Fine Arts: p. 21